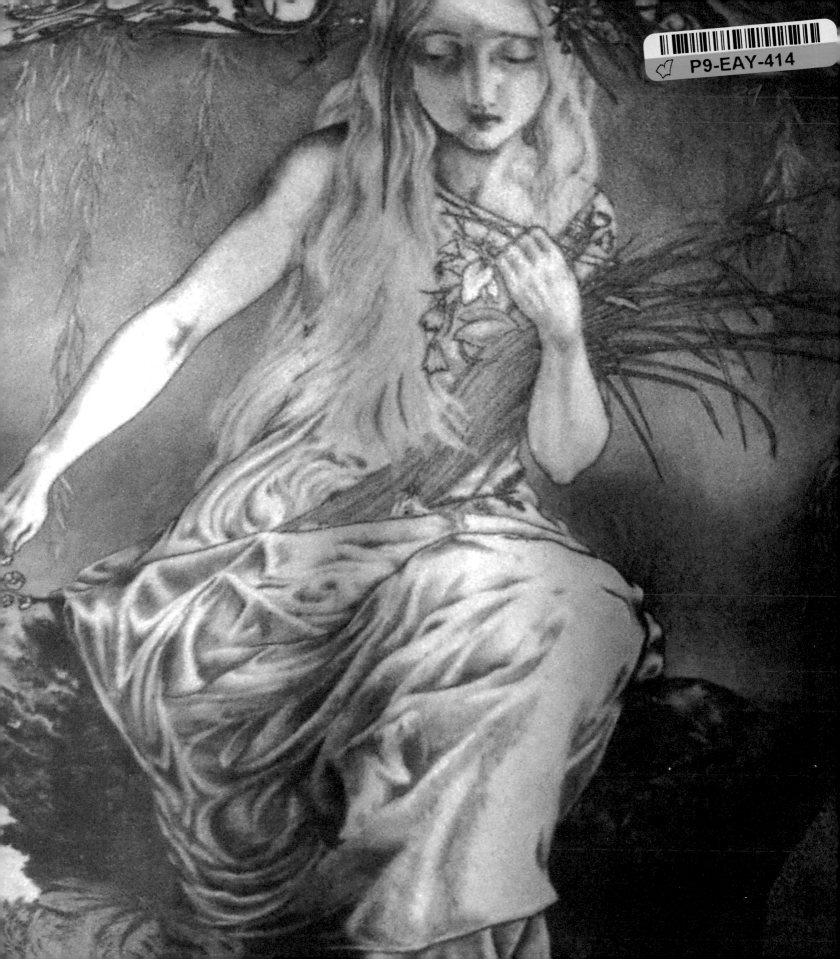

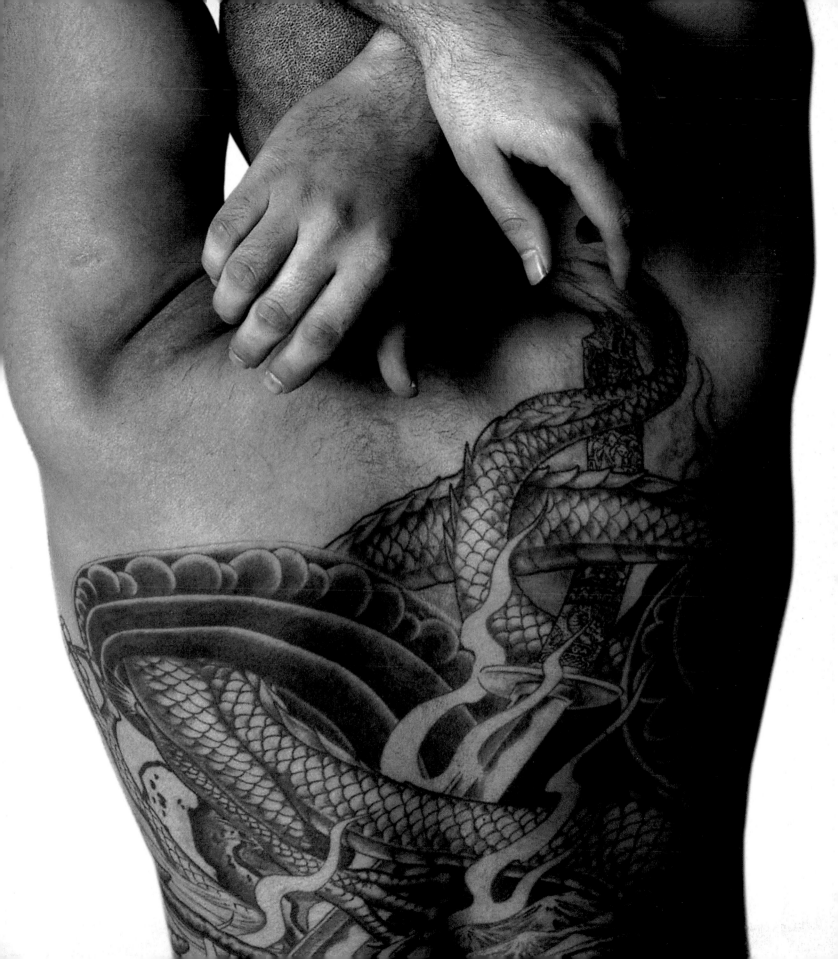

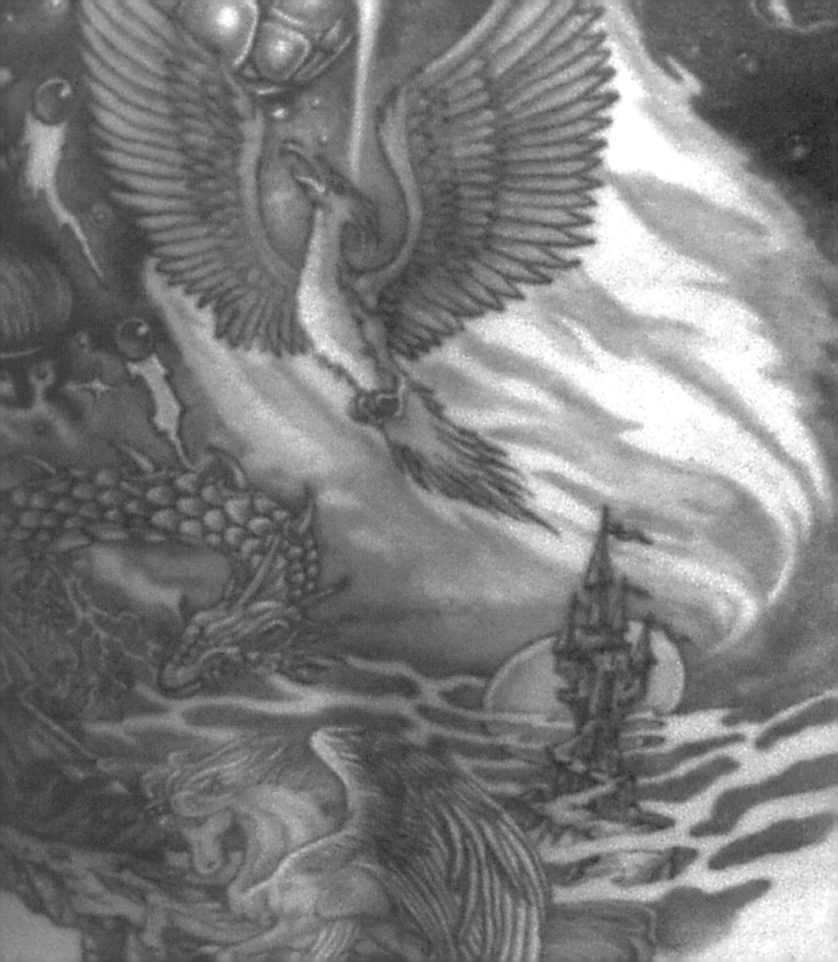

Body Art

The Human Canvas—Ink and Steel

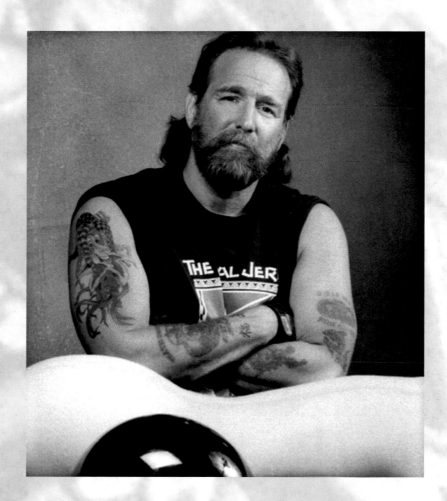

Gary Lee Heard

with David Cultrara

PORTLAND, OREGON

Visit Gary Lee Heard on the internet at www.garyleeheard.com

Design: Jeff Birndorf, endesign

Proofreader: Aimee Stoddard

Library of Congress Cataloging-in-Publication Data

Heard, Gary Lee.
 Body art : the human canvas--ink and steel / Gary Lee Heard with David Cultrara.-- 1st American ed.
 p. cm.
 ISBN 1-888054-84-0 (alk. paper)
 1. Tattooing. 2. Body piercing. I. Cultrara, David. II. Title.
 GN419.3.H35 2003
 391.6'5--dc21
 2003009542
Printed in Singapore

9 8 7 6 5 4 3 2 1

Collectors Press books are available at special discounts for bulk purchases, premiums, and promotions. Special editions, including personalized inserts or covers, and corporate logos, can be printed in quantity for special purposes. For further information contact: Special Sales, Collectors Press, Inc., P.O. Box 230986, Portland OR 97281. Toll free: 1-800-423-1848.

For a free catalog write: Collectors Press, Inc., P.O. Box 230986, Portland, OR 97281. Toll free: 1-800-423-1848 or visit our website at: collectorspress.com.

Artist Notes

by Gary Lee Heard

A number of things struck me about the people I photographed for this project. First and foremost was their willingness to share their body art. Every person photographed for this book walked into my studio (whether a makeshift tent plopped down in the middle of a convention hall or my formal studio) and immediately responded to my simple statement, "Show me your art in the way you are most comfortable." For some, their ink was easily seen; for others, the shirts came off, the pants came down, and with an immediate ease and comfort, these people proudly displayed their art. Their physiques didn't matter; they just wanted to show off their art. I think we all have a need to feel special and unique. The people I photographed used their tattoos to define their individuality.

I was also fascinated by the relationship between artists and their clients. Once people find an artist they are happy with, they won't go to anyone else. In many cases, body art becomes a collaboration where the subject has a design or perhaps just a concept in mind and then the artist takes that design or concept, adds his or her own creativity to it, and then transposes it onto the body. But it's really more than just a collaboration; the artist and client become linked emotionally. That symbiosis becomes especially heightened when the artist is doing a memorial tattoo. Many artists told me that because of the connection with their clients, they feel their clients' pain and their grief. They work hard to make the memorial tattoo a pleasant experience so that their clients remember the person not the pain.

And then there are the artists themselves – truly a unique group of individuals who are walking billboards of talent and creativity. Most of them have long since given up any desire to work within a mainstream environment, choosing instead to dedicate their lives to the art of body modification. They know that what they to do is permanent and they take their work seriously.

To all those I photographed for this project, whether you made it into this book or not, I just want you to know that you touched my life with your art, with your self-esteem, your candor, and your willingness to open your hearts and souls to my camera.

Thank you.

Gary Lee Heard

Introduction

by David Cultrara

Body art has existed for as long as humankind itself. The desire to alter one's appearance, whether it be for a practical purpose such as early people's need to camouflage for hunting and warfare or for decorative purposes, to attract members of the opposite sex, or just the need to impress ones fellow cave dwellers, body modification has been practiced since people first started recognizing their own reflections in the local watering hole. Even in nature, plants and animals practice forms of body modification au natural. Many species can change color or alter their size in order to elicit desired responses from friends or foes. For example, some male birds flash brilliantly colored feathers to impress the lady birds, while some reptiles and plants expose fiery red tones as a deterent to hungry neighbors.

In researching the world of body art, we found the reasons for indulging in body modification as varied as the subjects themselves. Some people modified their bodies in order to fit into a social group, some sought to satisfy a need for self-expression, while still others modified their bodies because they liked what they saw and thought others would, too.

As humans have evolved so too has the nature of body modification. Though modern body art has changed in methods and styles, some of today's desirable fashion statements are related to instincts that have been rooted in human behavior since the beginning.

Since the beginning of our involvement with the world of tattoos and piercing, the most commonly asked question has been "How long will this current fad last?" Some people ask with an honest curiosity, while others inquire with a sense of disdain for the entire tattoo and piercing "thing." I often got the impression that the latter were actually hoping that this whole body art fad would soon go away since they either rejected it as a much too severe change of style or were threatened by what they saw as the fad's drastic nature and permanence. My favorite responses to the fad question has always been in the form of a recent history lesson. I inform these curious people that just a few hundred years ago wearing a simple pair of hoop earrings was viewed as an extreme practice. A person was stereotyped as some kind of gypsy, or worse, a practitioner of the dark arts. While fashions have evolved, certain negative instincts and reactions to change still exist. However, with the exception of extremely closed-minded people, most observers of body art have lost the desire to burn the tattooed and pierced at the stake — well, not literally anyway.

The reasons people become involved in the body art experience are as varied as the people themselves. These reasons range from a need for self-expression, a desire to have a permanent remembrance, to an appreciation of art for art's sake. By definition, all tattoos and piercings are a form of self-expression. The reason people indulge in body art can be very simple or very complex and as involved as the artwork itself. The woman whose response was "why not?" might just have a cavalier attitude, or she might be exhibiting a nonconformist and confrontational nature. The extent and intensity of a person's body art may also be a barometer of the level of desire for self-expression.

We met and photographed a woman whose name was Lady Amazon (we checked her drivers license, that was her legal name). This woman had suffered the tragic loss of a daughter who was killed in a house fire. As a testament to her daughter and her loss, Lady Amazon had a full back tattoo. The artwork was a very personal portrayal of her memory of her child. Lady Amazon was definitely a unique individual with a very outgoing, warm, and effervescent personality. She chose to honor her daughter through a most personal medium — her body.

Though the old cliché "don't judge a book by its cover" certainly does apply to body art, in many instances it is a safe bet that the volume or intensity of a tattoo or the sheer tonnage of steel people sport on their bodies may very well be a window into their personalities. Though much of body art is just a simple expression of personal style, many who become involved in body modification express a need to communicate a much deeper and intense message, whether it be to those in their immediate social circles or to society in general.

These messages can be positive or negative, a show of defiance and nonconformity, or just the opposite, an attempt to conform to the environment in which they exist. In the case of defiance, people may choose their body art for the sheer shock value of it, or as a vehicle to express a certain attitude or feeling. They may feel at odds and out of control with the world around them. They empower themselves in an environment where they may otherwise feel powerless.

The use of body art to create a sense of acceptance in social circles is just as strong as a tradition of using body art as a platform to portray non conformance. There are similarities among the rite of passage in an aboriginal tribe, the young person of today who feels the peer pressure to be cool like the rest of the crowd, the biker who wants to fit in by proving how much of an outlaw he or she is by their rebellious ink, and the sailor who wants to show he's as much a salty dog as the next guy in the boat. These are all examples of a desire for inclusion as opposed to a desire to reject the norm. Interestingly enough while we were conducting interviews with subjects for this book, I assumed the typical prison tattoos would be a perfect example of an attempt at inclusion through body art. However, when

I got to know people who obtained their body modification while in prison, I learned that most of them actually got involved in body art because they were simply bored and had a lot of time to kill, with generally one exception: the gang member tattoos. The example of gang insignia tattoos underscores the use of body art as a method of conformity and is related to human's tribal origins. The gang tattoo shows to the world that the gang members are not alone and that they are proud to be permanently branded into the gang. This is as true and meaningful to the prison and street gang as are the patches or insignias worn by more socially accepted groups like the Boy Scouts or branches of the military.

Then finally there is probably the most simplistic desire of all for indulging in body art — fashion. Men and women nowadays are getting tattooed and pierced for the most basic reason of all: they just like the way it looks. Tattoos and piercings have become a much more acceptable practice, to the point where much of today's body art has evolved into the mainstream of style. This new wave of body art enthusiasts are not wild bikers, desperate gang bangers or rebels without a cause. They are exhibiting the same basic desire to adorn themselves that humans have expressed throughout time. Just as they purchase the most fashionable clothing and drive the hottest new cars, people are now becoming more and more comfortable having permanent works of body art and are proud to show off their new plumage to the world. This latest group of body mod practitioners is what has really exploded the pop culture world of tattoos and piercing. What was once the fashion domain of the extremists has now become as common as blue jeans and designer sunglasses. The origins of body art may indeed date back to tribal rituals; however, body art has now evolved to the point of becoming part of everyday life.

That simple pair of hoop earrings that upset polite society back in the day, has now been joined on today's lists of acceptable adornment by pieces of steel and gold in the navel, nose, and eyebrow.

Though simple tattoos and basic body piercings have become almost commonplace, there are still examples of body art that remain on the fringe of what is considered to be acceptable behavior. The tongue piercing for example, although more and more common, is still to many people very strange and to some quite grotesque. Full body tattoos as well as the practice of large gauge and multiple piercings are also considered on the fringe, even by those who have dabbled in the body modification experience. Though these forms of body art may still be looked upon as extreme, we must remember that history has taught us that today's eccentricities may become tomorrow's norms.

Aside from the obvious physical aspects of body modification, there may also be another, equally personal, metamorphosis taking place. During the experience of body modification, there is a certain bond that is created between the artist and

HIS OR HER HUMAN CANVAS. PEOPLE RECEIVING THE TATTOO OR BODY PIERCING OFTEN BECOME CONNECTED TO THE ARTIST MUCH THE WAY PATIENTS FEEL CONNECTED TO THEIR PHYSICIAN OR A VIRGIN TO HIS OR HER FIRST LOVE. THIS HAS TO DO WITH HAVING ONE PERSON ENTER THE VERY PERSONAL SPACE OF ANOTHER. JUST AS ONE MAY FEEL POWERFUL EMOTIONS FOR HIS OR HER FIRST LOVER, THERE'S THAT EMOTIONAL CONNECTION THAT COMES FROM HAVING ONE'S PHYSICAL BEING PENETRATED BY ANOTHER'S TOUCH. THE EXPERIENCE CAN BE BOTH POSITIVE AND NEGATIVE. JUST AS THE VIRGIN MAY BECOME ENAMORED WITH HIS OR HER FIRST LOVE AND FIRST EXPERIENCE, SO MAY THE PERSON BE CONNECTED TO HIS OR HER ARTIST. SOME FIRST TIMERS MOVE ON WITH NO REGRETS WHILE OTHERS MAY CARRY A FEELING OF HAVING MADE A BAD DECISION FOR THE REST OF THEIR LIVES. SOME ARE ENAMORED WITH THE PROCESS AND CARRY ON WITH A HEALTHY DESIRE FOR MORE. IN OTHER INSTANCES, A PERSON BECOMES OBSESSED AND ADDICTED TO THE PROCESS — IF NOT THE ACTUAL ARTIST.

THERE WERE TWO MAIN GOALS WE WANTED TO ACCOMPLISH IN THIS BOOK. THE FIRST WAS TO EXPOSE THE MANY SIDES OF THE SUBJECTS PHOTOGRAPHED — THE ATTITUDES, DESIRES AND INSPIRATIONS BEHIND THEIR INVOLVEMENT IN BODY ART. WE BELIEVED IT WAS JUST AS IMPORTANT TO OFFER A GLIMPSE INTO THEIR PERSONALITIES AS IT WAS TO SHOWCASE THEIR BODY ART.

THE SECOND GOAL WAS TO DOCUMENT INSPIRED ARTWORK, ON A PERSONAL AND INTIMATE LEVEL, TO BOTH THOSE ALREADY PARTICIPATING IN BODY MODIFICATION AND TO THOSE PEOPLE CURIOUS BUT OUTSIDE THE WORLD OF BODY MODIFICATION — TO EXHIBIT TO BOTH THE AFICIONADO AND THE UNINITIATED A MYRIAD OF BODY ART IN A STYLIZED AND REVEALING FASHION WAS THIS BOOK'S ULTIMATE PURPOSE.

"I had my navel pierced at a Daytona bike show in 1992, long before navel piercing was commonplace. I got a kick out of the fact that getting my navel pierced grossed out all the big bad bikers I was with.

~Karen Budziszewski

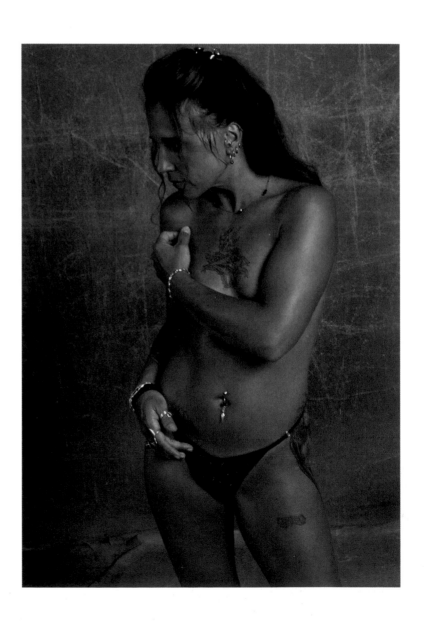

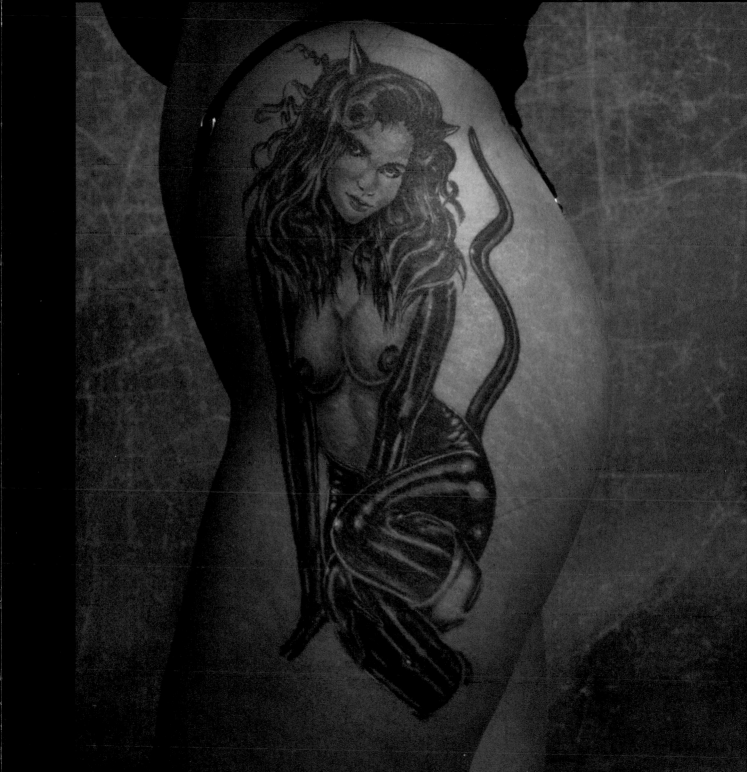

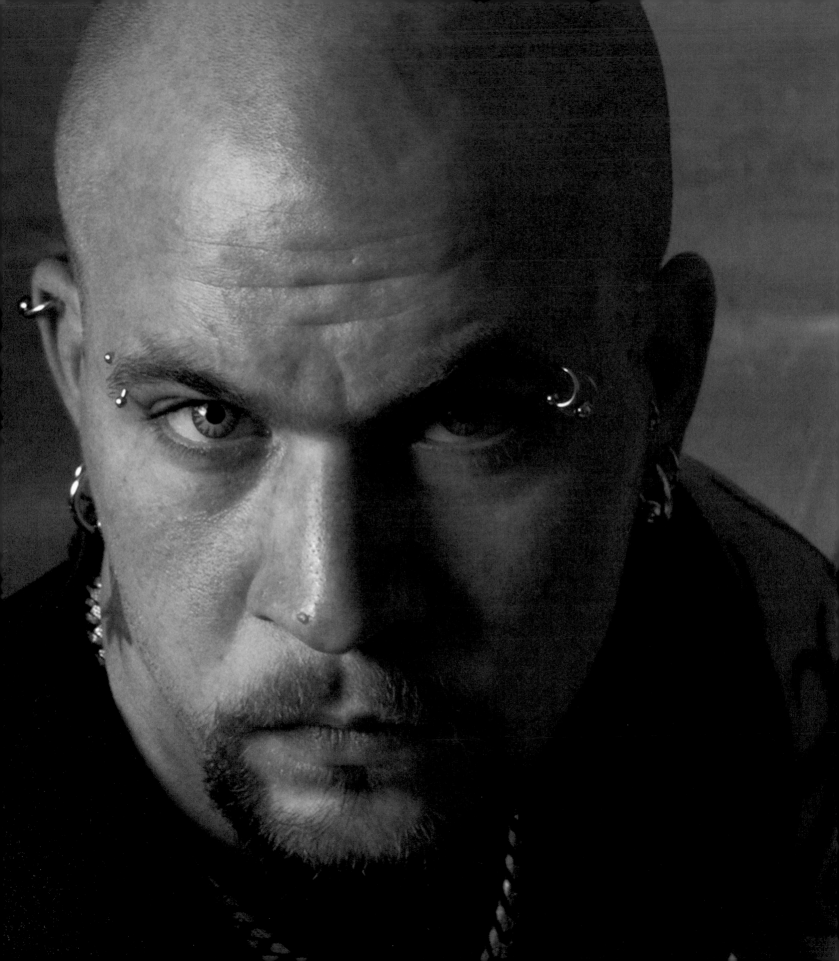

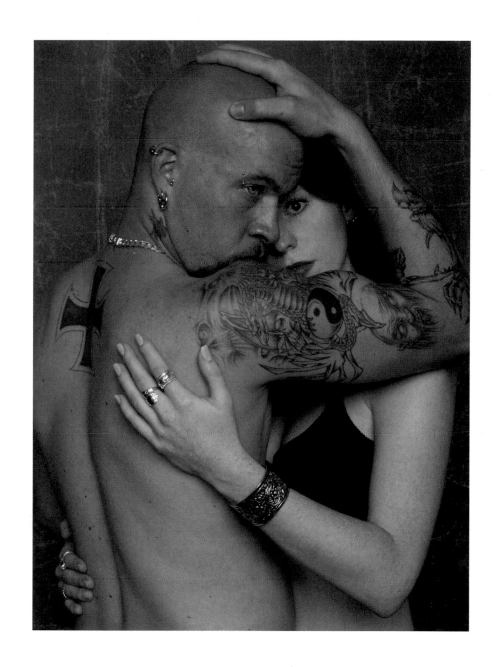

My first tattoo was the result of true love. The tat is a yellow rose with "Pammy" in a ribbon under the rose. After the rose was done, I asked the ink slinger to put my wife's name under it, he said that if he did that I'd loose her for sure. I told him do it anyway. To make a long story short, he charged me $5 more for the ink, $20 for the flower and $5 for the name. That was 31 years ago and we're still together, nuf said.

The rest of my ink is all about things that are dear to me. It brings people that I like to be with close to me and the ones that I have nothing in common… my ink scares them away. That way I don't have to deal with there uptight asses.

To have an artist put their art into my skin bonds the artist and myself in a way you can't explain. If I had to explain, you wouldn't understand anyway, unless you've been there.

A new tat is better than a haircut and will last till ya die.

~Jeff List

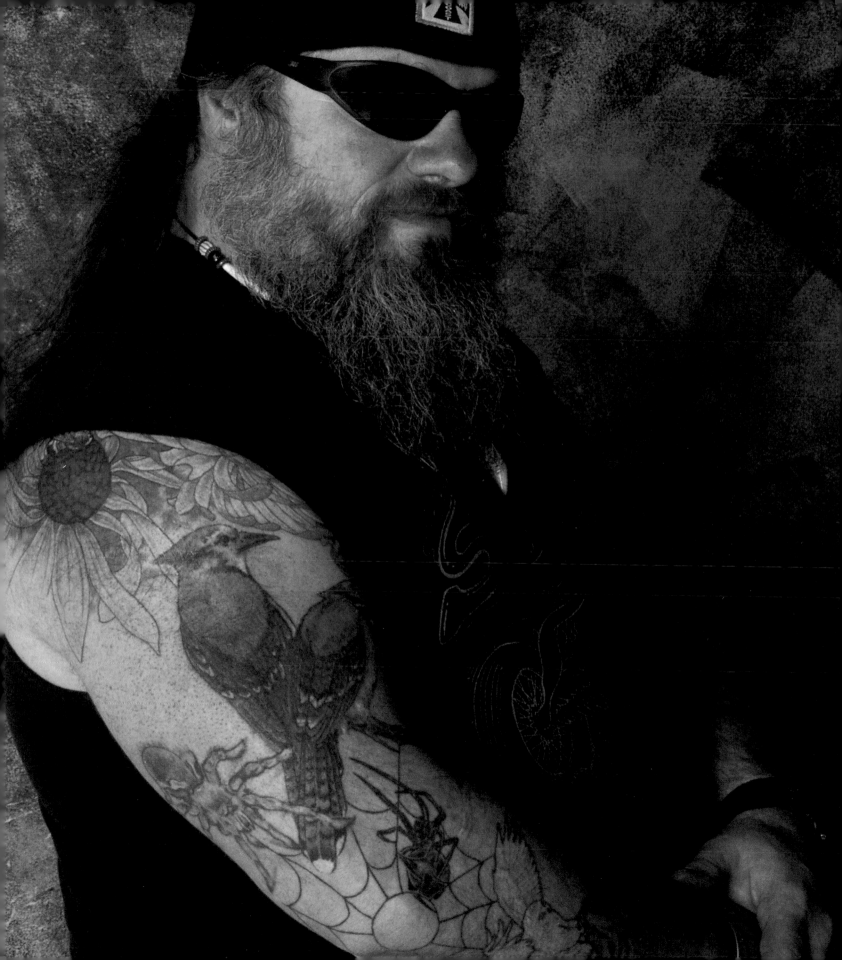

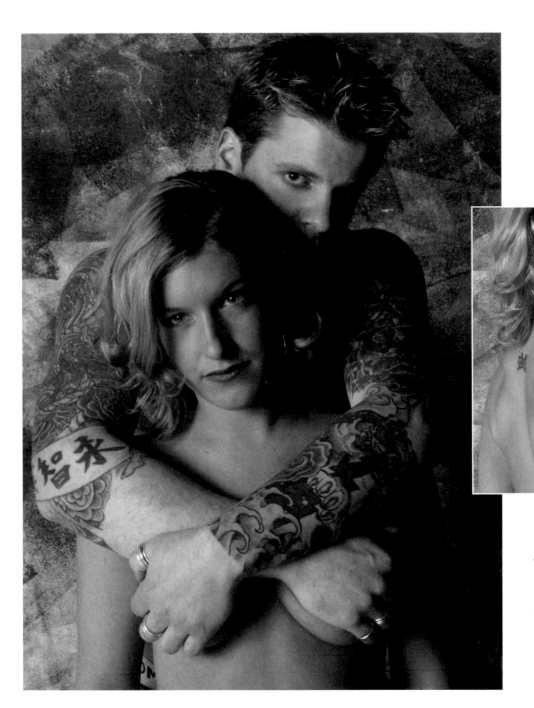

To be unique.

~Rachel Rosa

i'm really just a teddy bear who loves his daughter – not some freak.

~Mark Ippalto

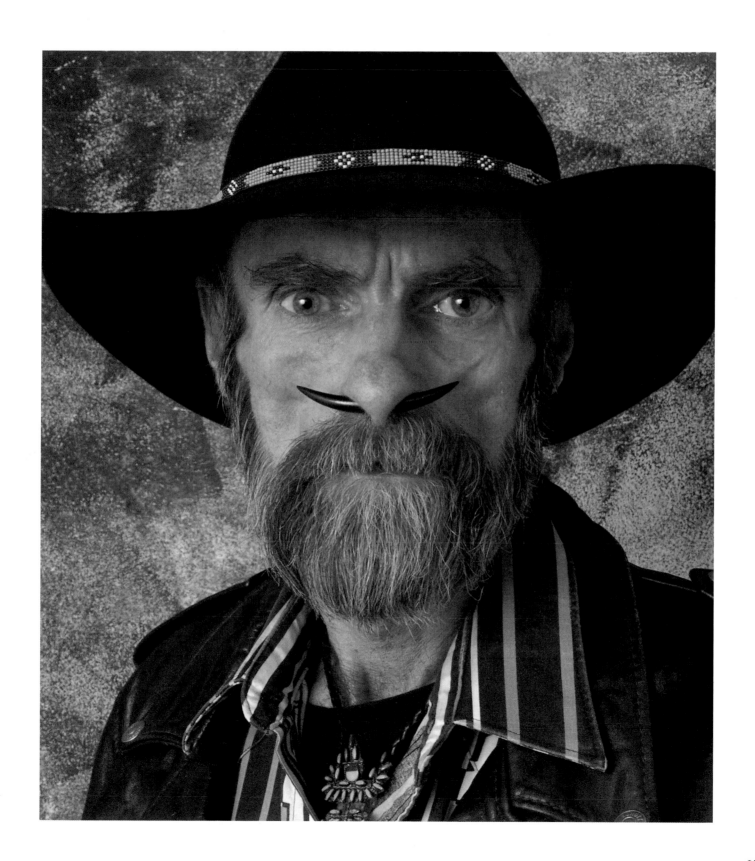

17

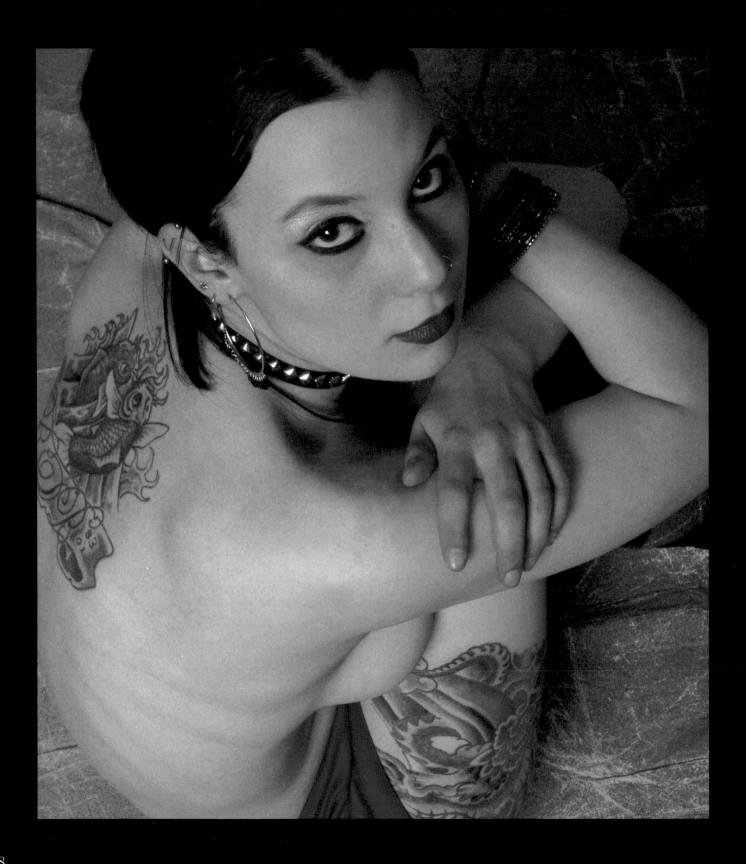

The most negative reaction I ever got from my tattoos was when my mother and I went to Disney World for spring break. A man sitting by the pool told me that my work was "atrocious" and that he would kill his children if they ever did that.

Tattoos are an external expression of the internal self. A lot of things that I wouldn't show outwardly I can express through my body art.

~Laura Vercolen

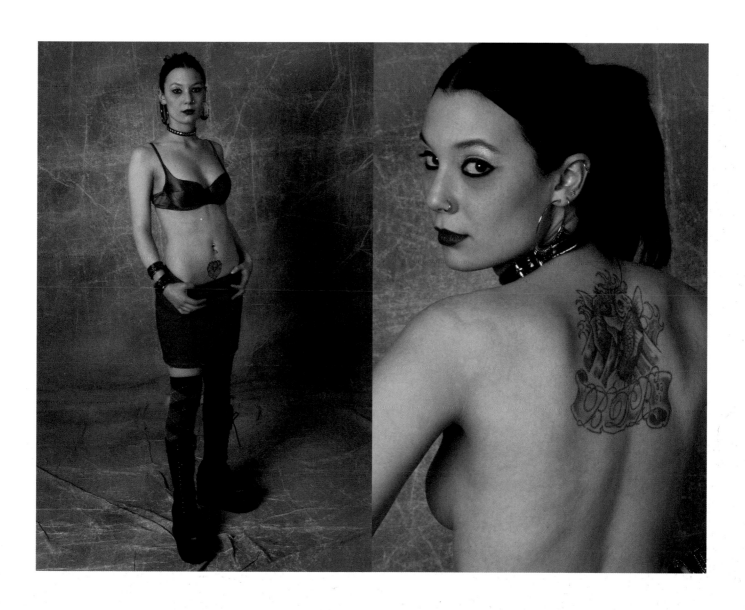

I do get some bad reactions, but give me 5 minutes and I can change anyone's mind! "

~Kelly Geistler

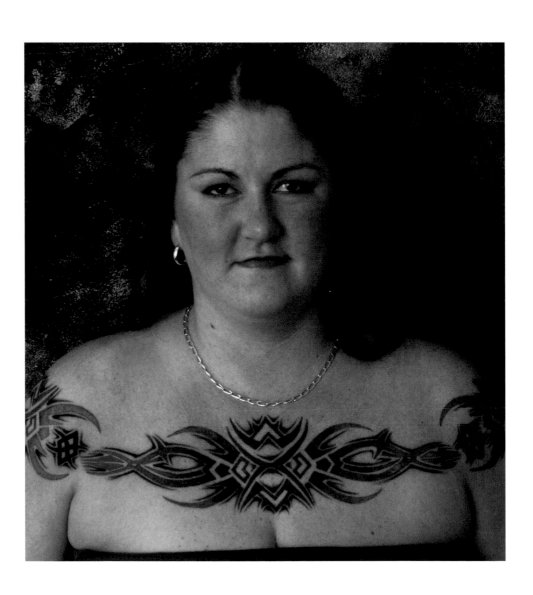

Most like my tattoos. The ones who don't, don't count anyway.

~David Klinetob

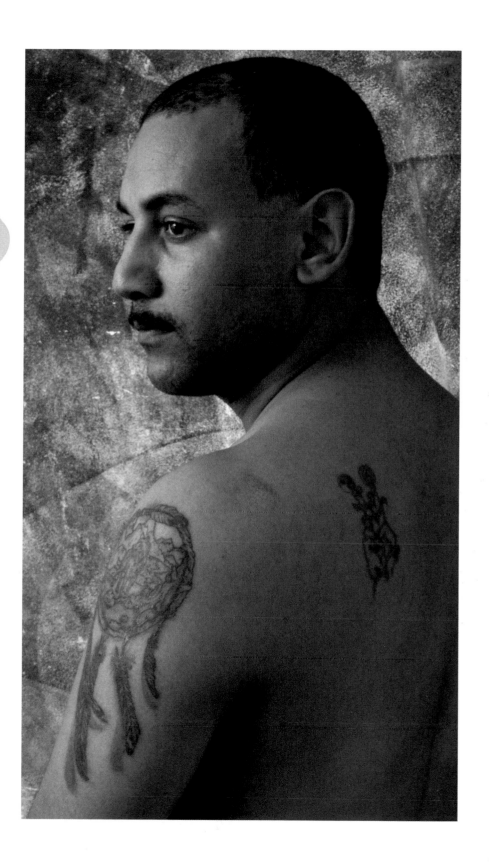

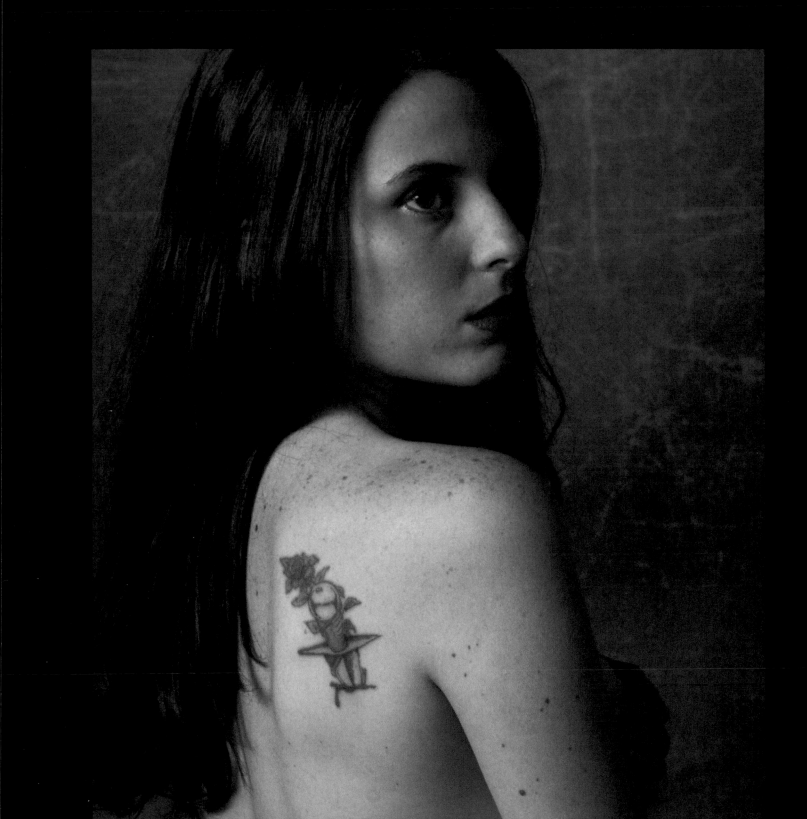

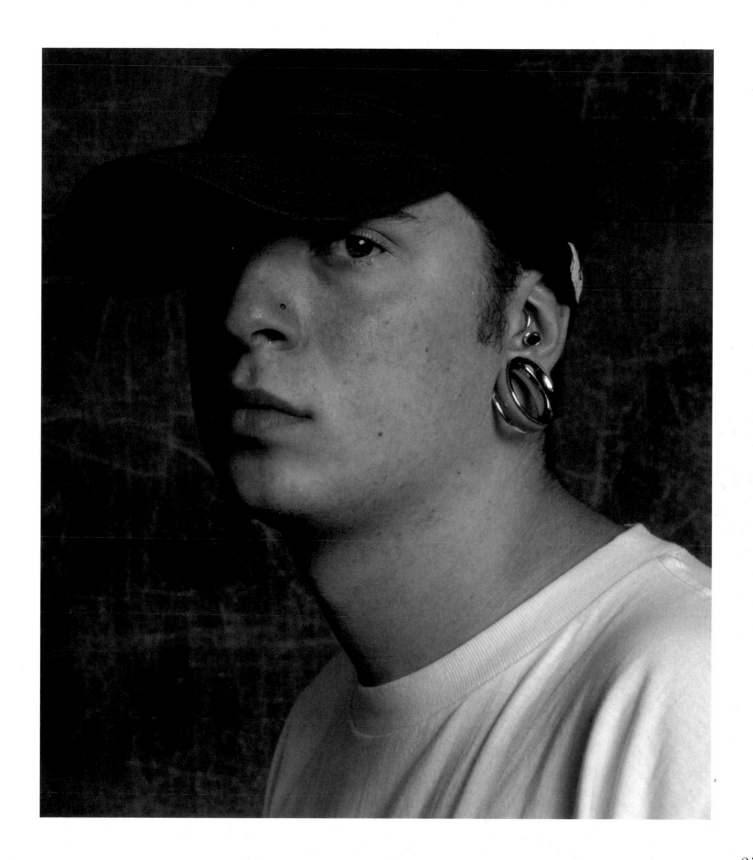

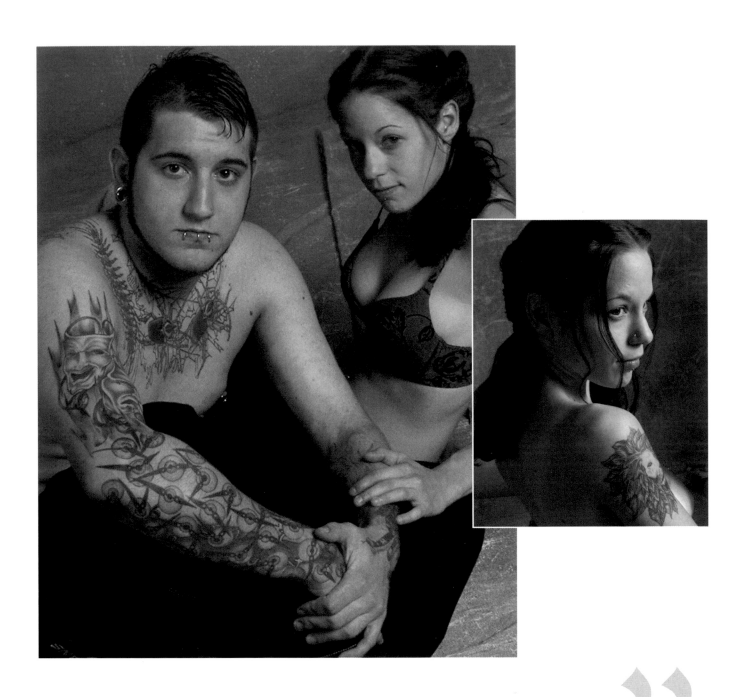

My mother first freaked out at the idea of me getting a tattoo, especially a large full shoulder tattoo of a lion. When I got the tattoo, though, my mother's heart melted when she saw the lion, it was from my favorite childhood book, the first book that my mother had given me. My mother now shows off my ink with pride to all her friends.

~Nicole Reyna

Can't separate brothers, not even through death. We were just that
close, so to have him on my arm says it all.

My tattoos come from the heart. One to remember the one who went
before me, and the other a spawn with angel wings — lets me know there
are two sides that want to claim us — so we have to choose.

~Robert Works

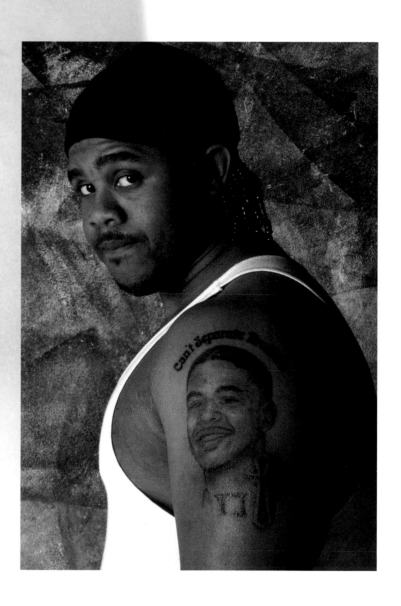

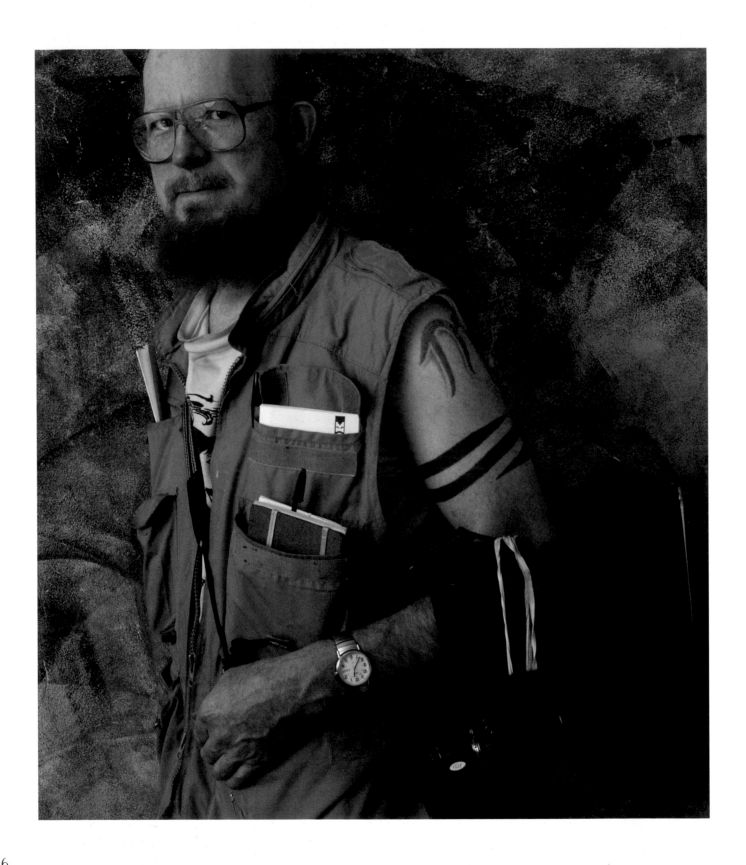

I JUST HAVE A REAL GOOD SENSE OF HUMOR. AND IF PEOPLE CAN'T TAKE A JOKE, THEY CAN GO FUCK THEMSELVES.

~STEVE FORD

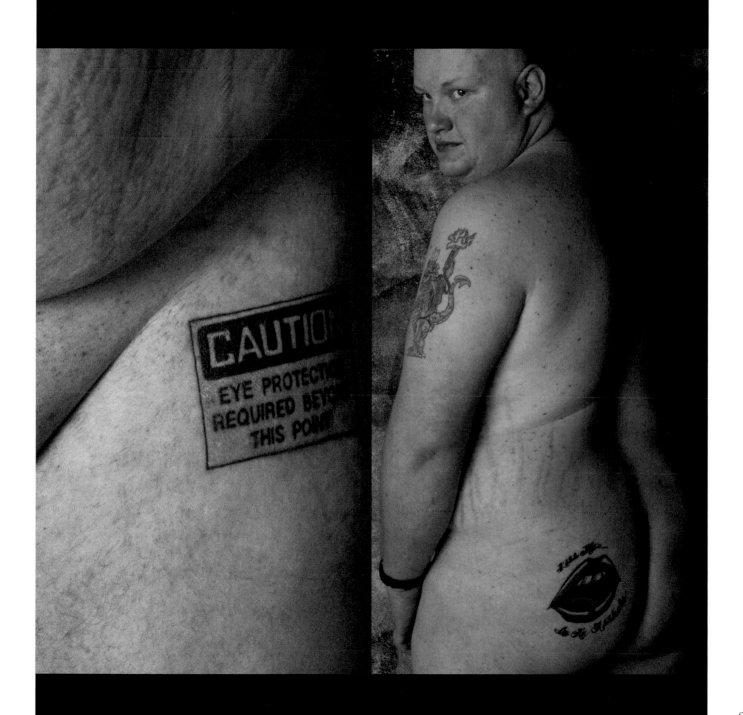

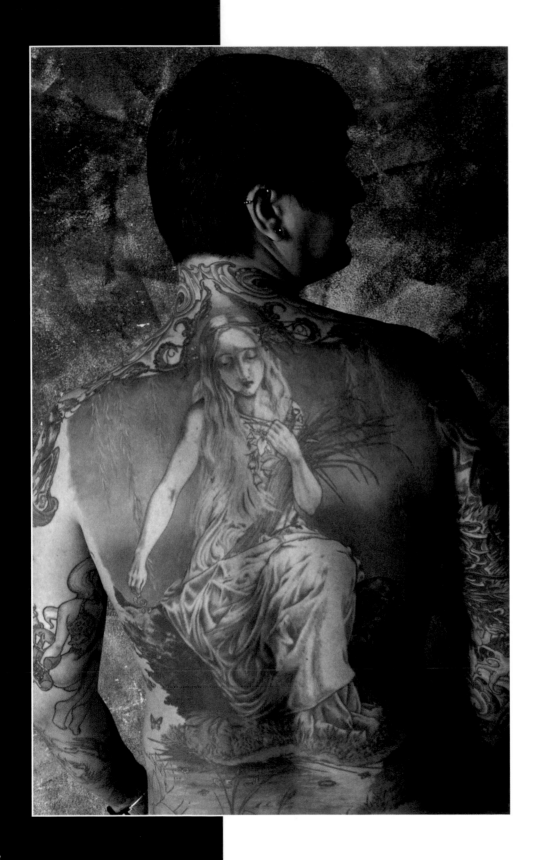

The inspiration for getting my first tattoo and piercing was that I wanted to be unique, identifiable, beautifully colorful and give a message to everyone — all at the same time.

What I would like others to know about me is that I do not fit any one stereotype. I like being an individual. I am a body piercer who enjoys all types of art and all types of music. I am also a trance DJ who is working on producing music on my own.

I love tattoos, piercings and music. How can that be a bad thing?

~Robert Mayer

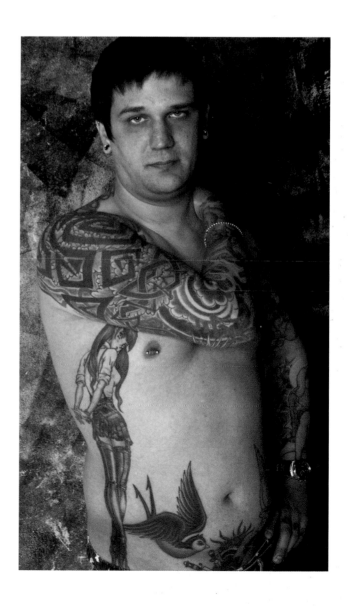

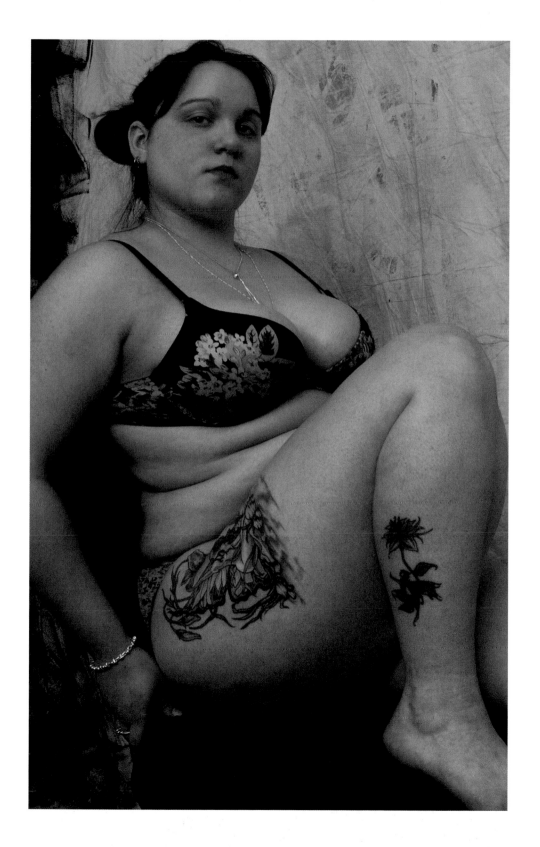

I AM A PROFESSIONAL PERSON AND AM STILL ABLE TO FUNCTION — I WOULDN'T CHANGE MY LIFE AROUND JUST BECAUSE I HAVE TATTOOS. ALSO, I'M AN EMT, AND WHEN I GET HASSLED ABOUT JOBS, I ALWAYS SAY "I CAN SAVE LIVES WHETHER I'M WHITE, PURPLE, GREEN, OR ORANGE."

THE QUESTION IS: ARE YOU GONNA LET SOME COLOR COME BETWEEN YOU & SOME OXYGEN? I CONSIDER MYSELF A TRUE COLORED PERSON!

~MORGAN NAVARRO

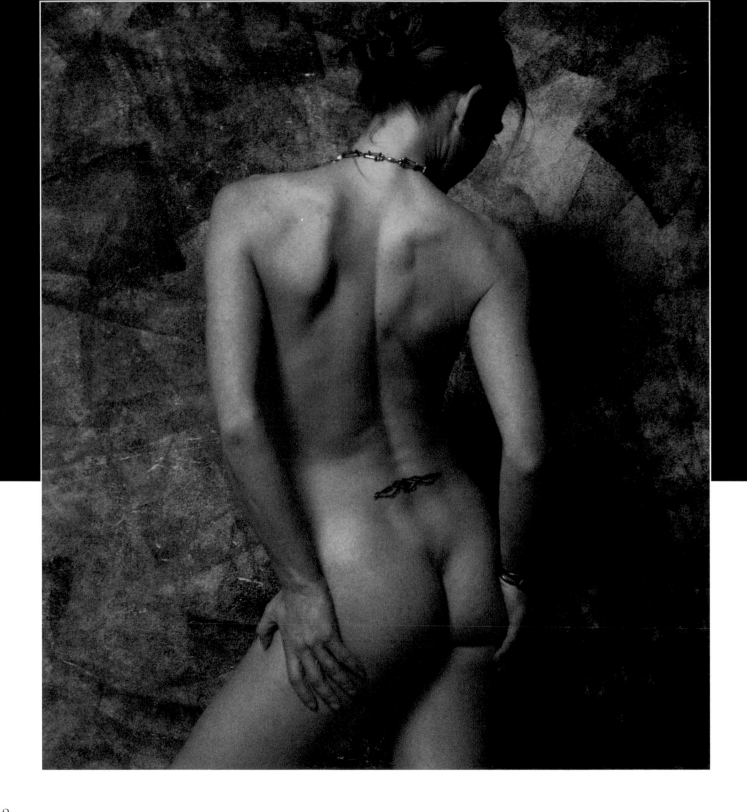

Body modification is more than a fashion statement. It's a way of life. A person's unique, individual sense of self. Every human is different, so is every piercing. Piercing is not a fad, but a culture shared by millions of people across the globe. It is a social norm, a social taboo, a fashion statement of the inner self, a culture, a religion, an occupation, an industry, and here to stay.

~Jason Morningstar

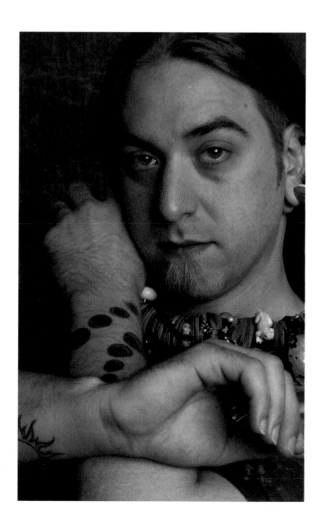

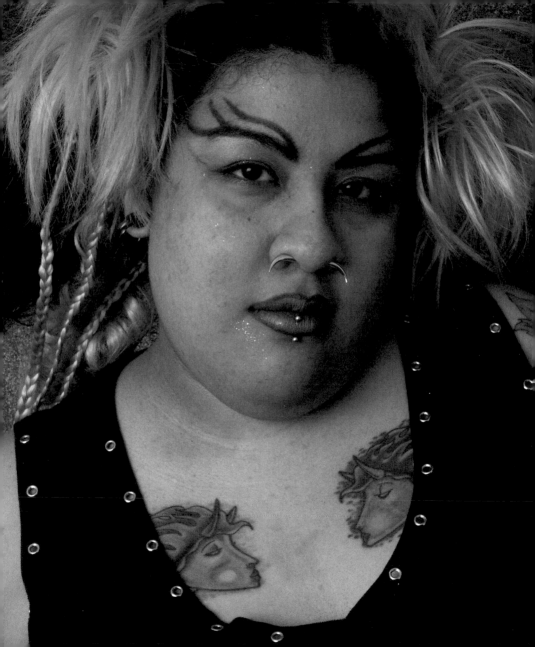

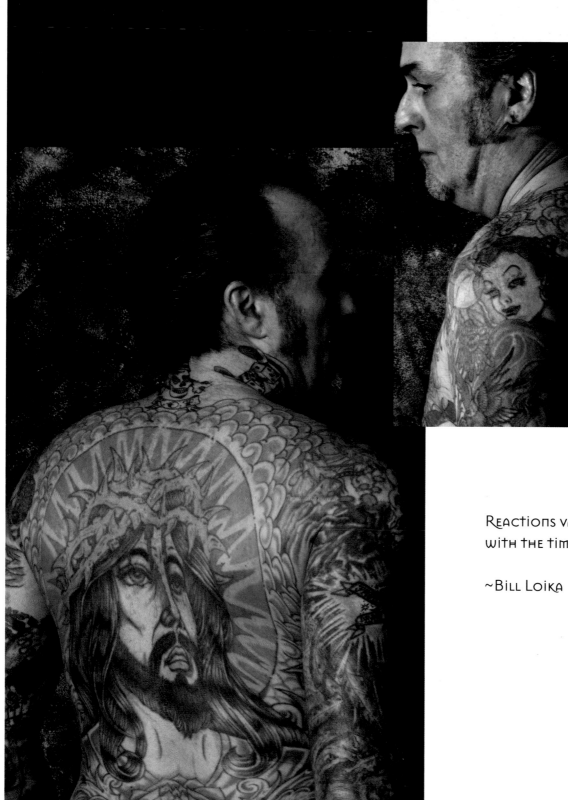

Reactions vary and change with the time.

~Bill Loika

I've been to the Museum of Modern Art, in a room full of some of the most famous paintings in the world, and I had a little crowd around me asking me about my arm. The mothers always tell their kids to thank "the man" for telling them about the people on his arm.

~Brian Torrey

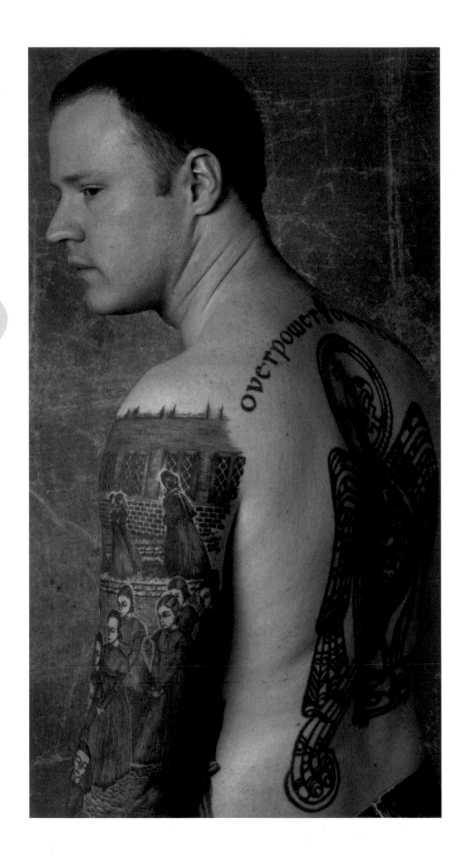

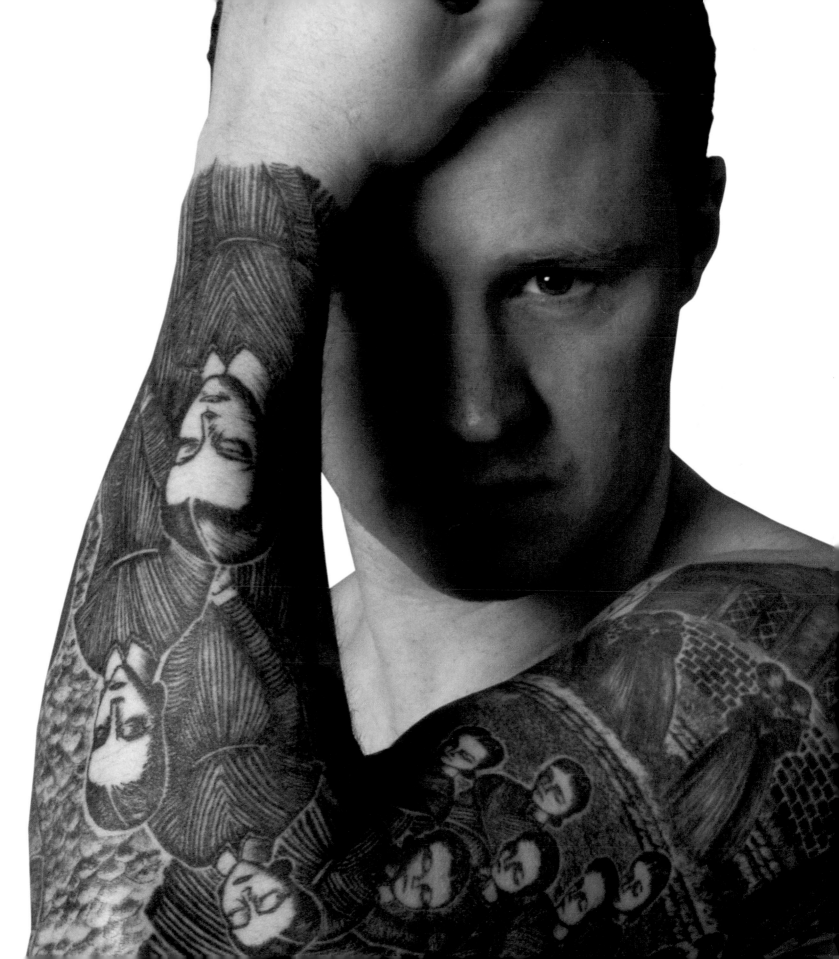

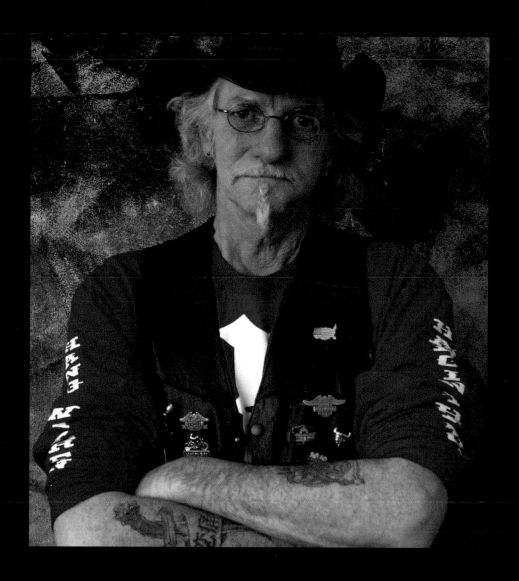

A few years ago I went through a time of my life that I lost everything and decided to do a cover up of how I felt. My Chinese tattoo means love hurts, I designed the clown head on a knife to cut out the pain.

~Dave Beer

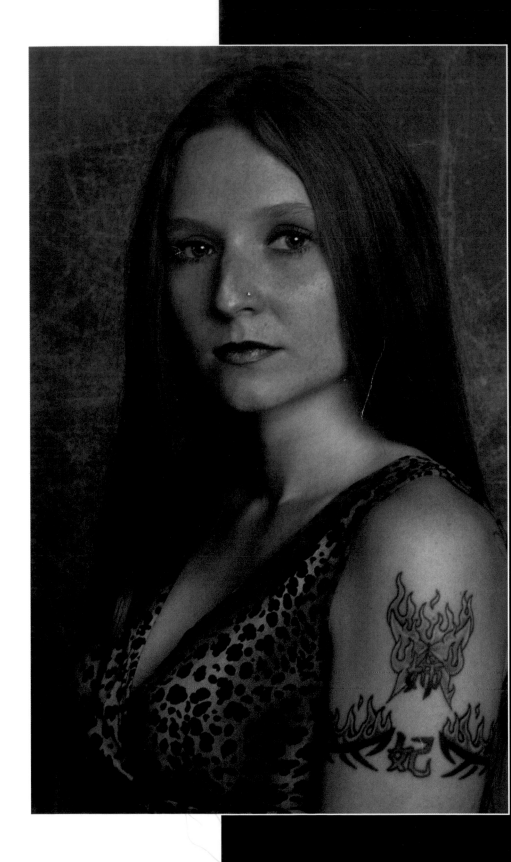

Body Art is a wonderful thing! Both tattoos and piercings are great!

~Shari Granda

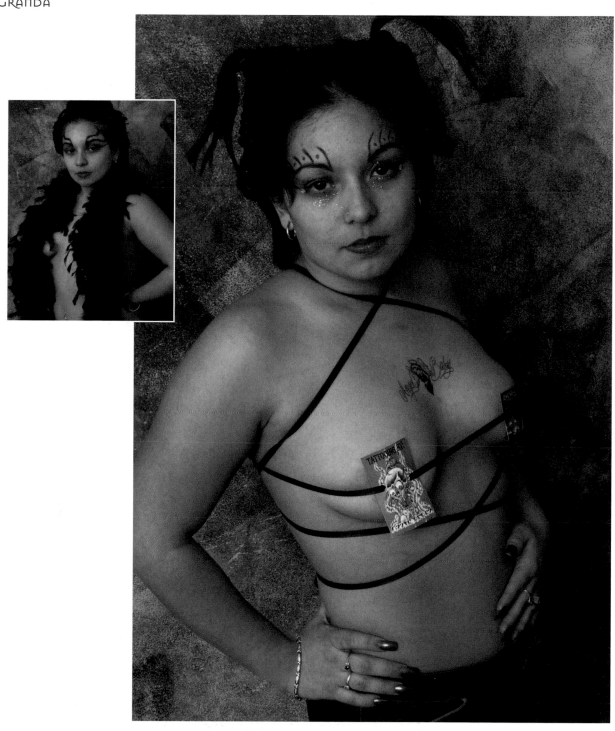

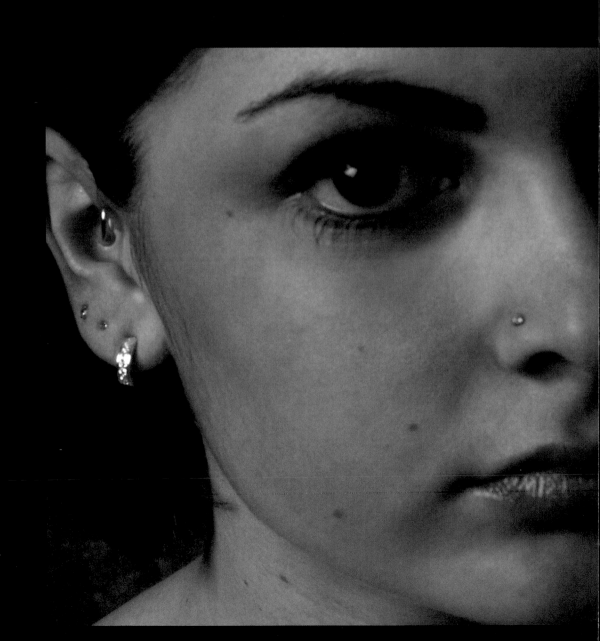

I always liked the way piercings & tattoos looked. With tattoos & different piercings, it sets you apart from people. Not many people can have a tattoo or piercing and still look the same.

~Karla Feola

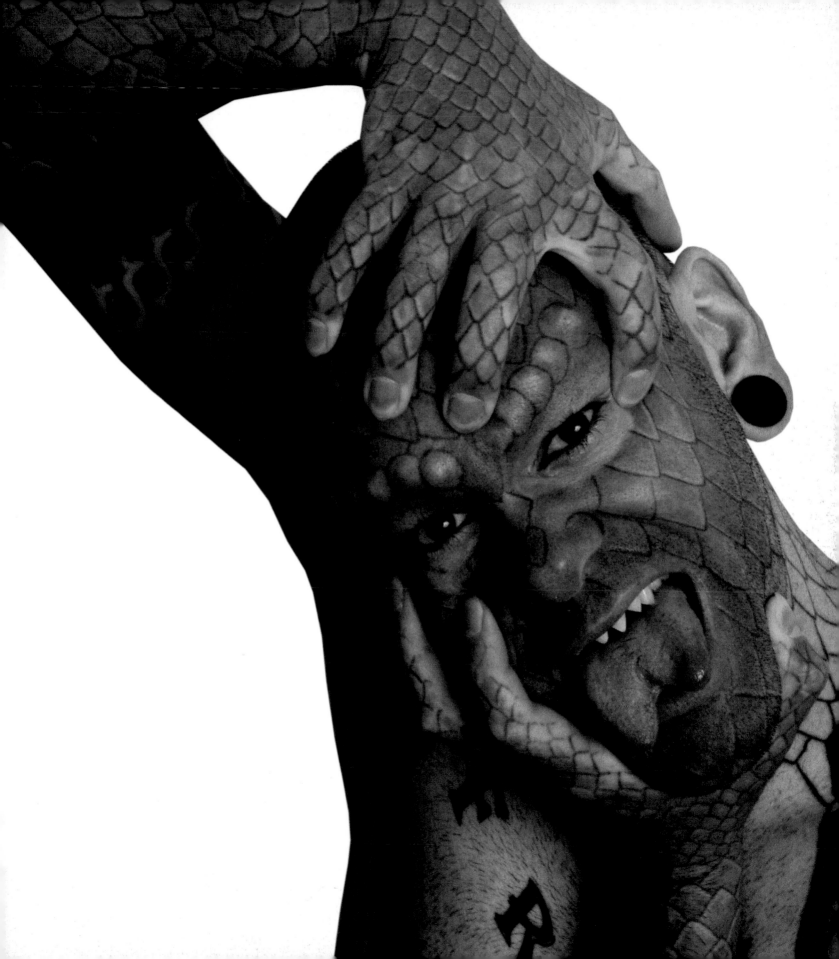

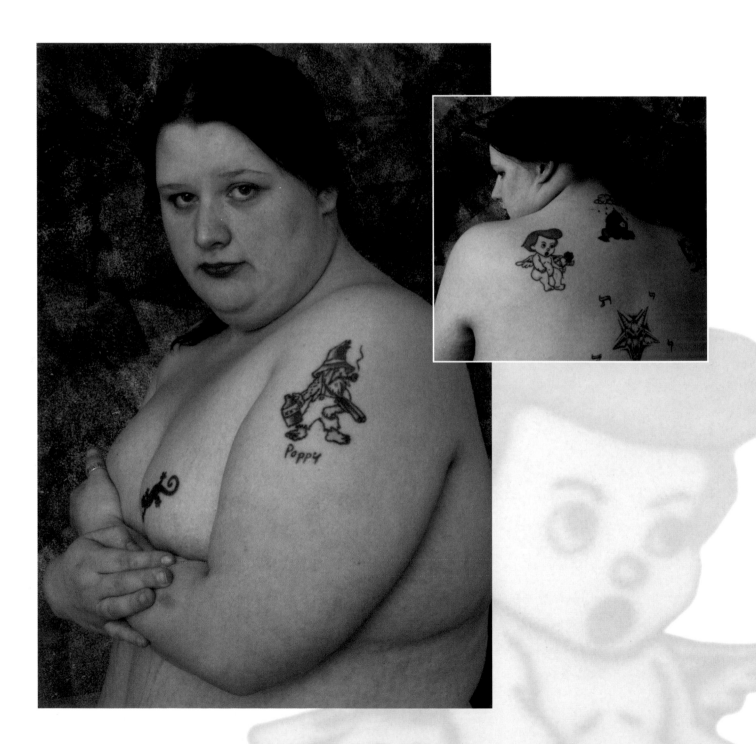

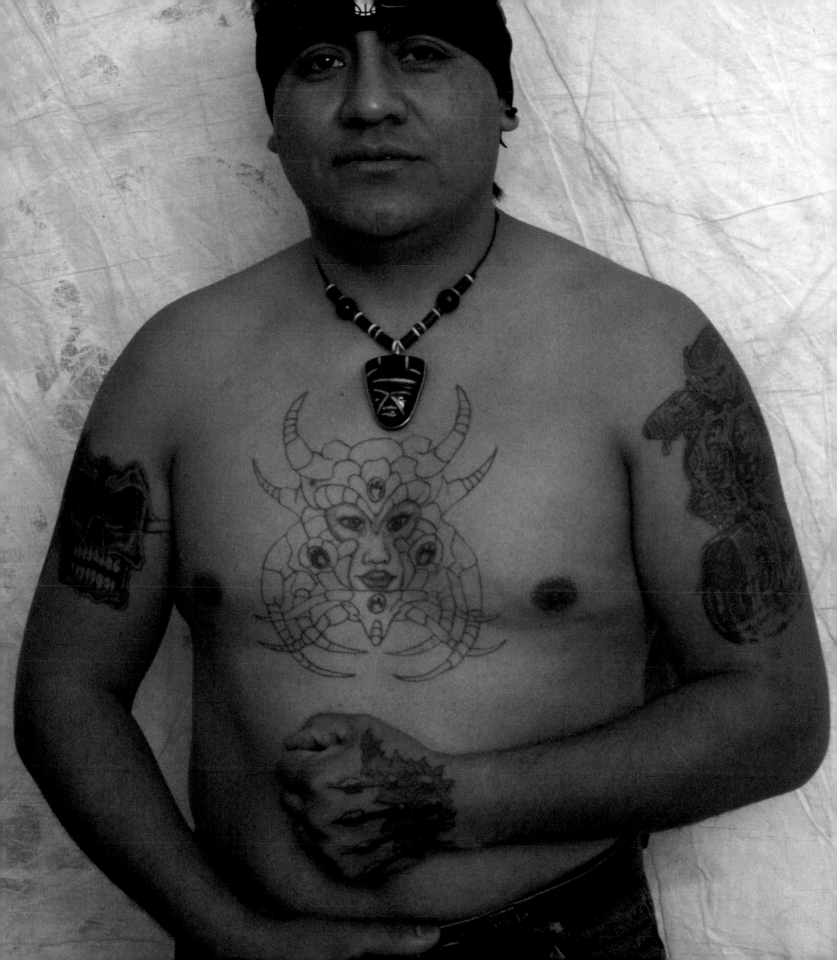

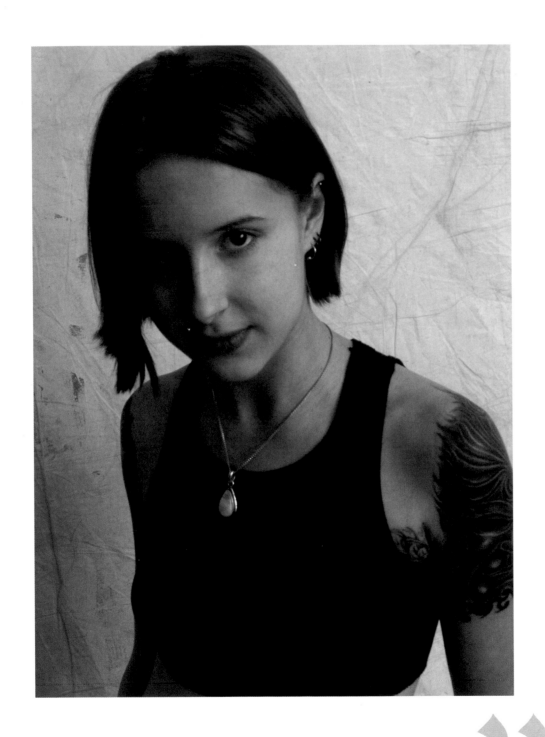

Strangers are very nice sometimes, especially since I'm not their kid. "

~Letitra Persons

My back piece is a story and a memorial of my daughter, Seneca, who died in an arson fire. Also, that my spirit rose like the phoenix from the ashes to live for the two of us. Through her death, I decided to live again, starting from ground zero.

~Lady Amazon Brown

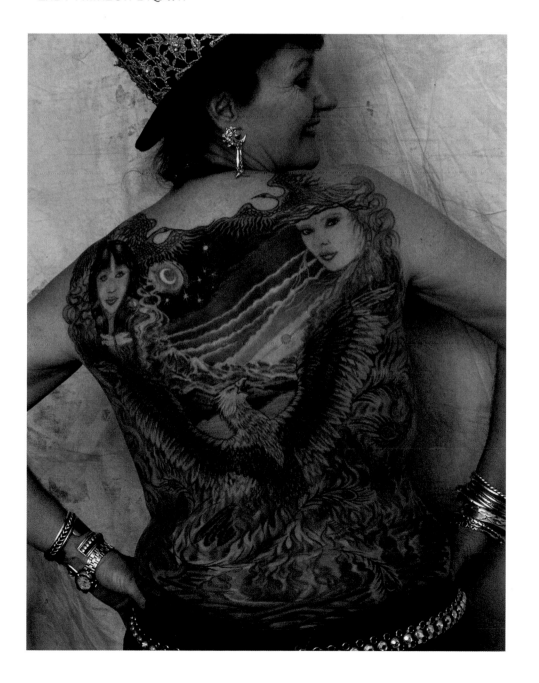

I am more than my physical body! My body
is a temple, my spiritual temple, and this
temple is ornate.

This is not a narcissist's quest! This is not
a childish rebellion!

This is about control of my body and
spirit. This is about physical trials, and the
resulting spiritual awakening.

This is about aesthetics!

This is about creativity!

This is about expression in its oldest and
purest form.

I am my art!

~Nick Giordano

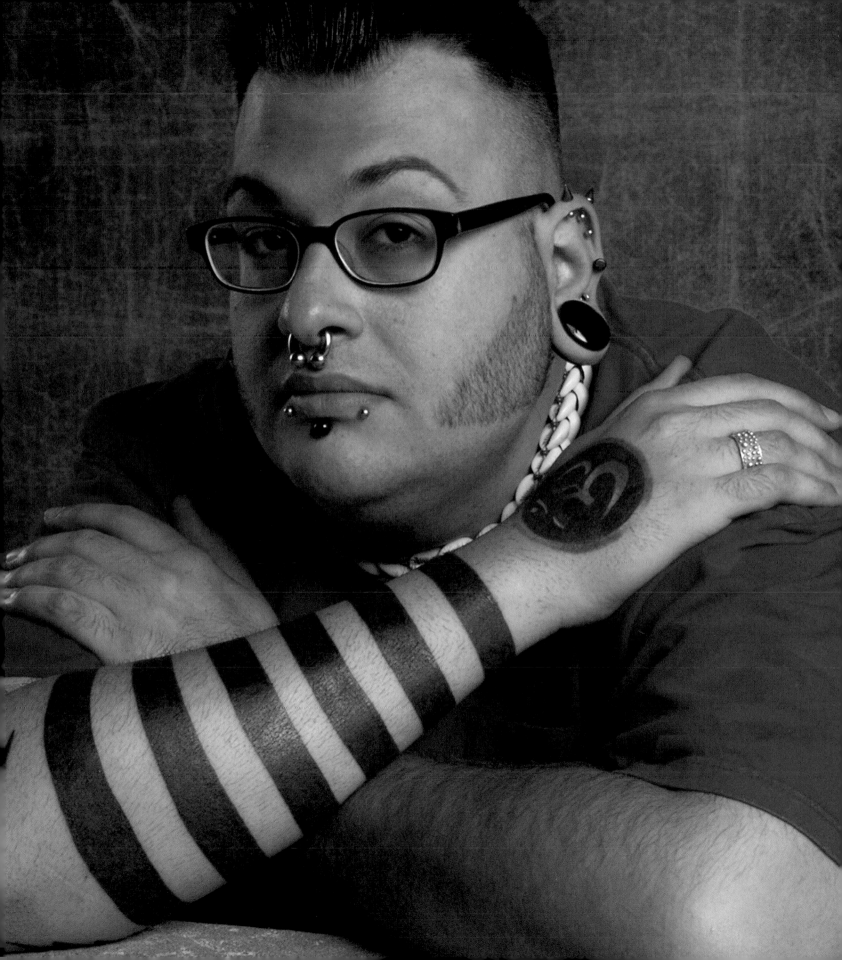

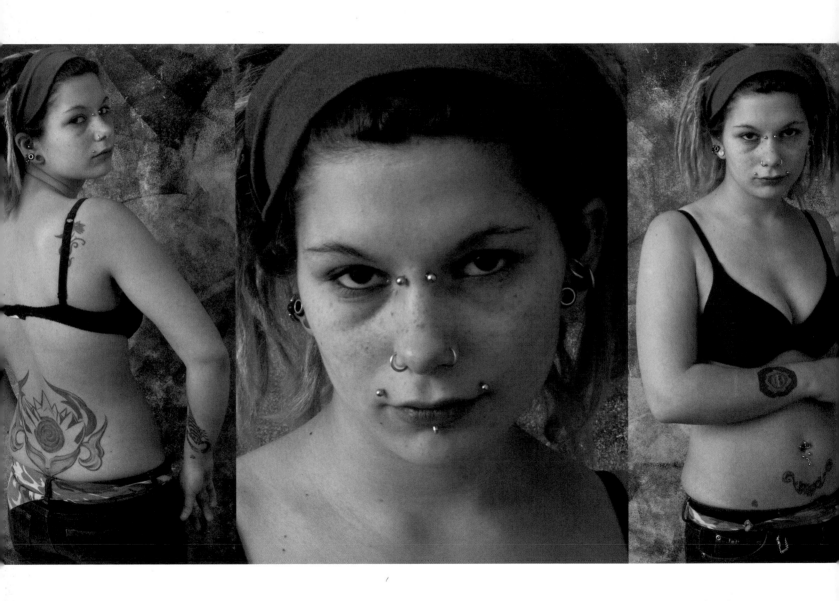

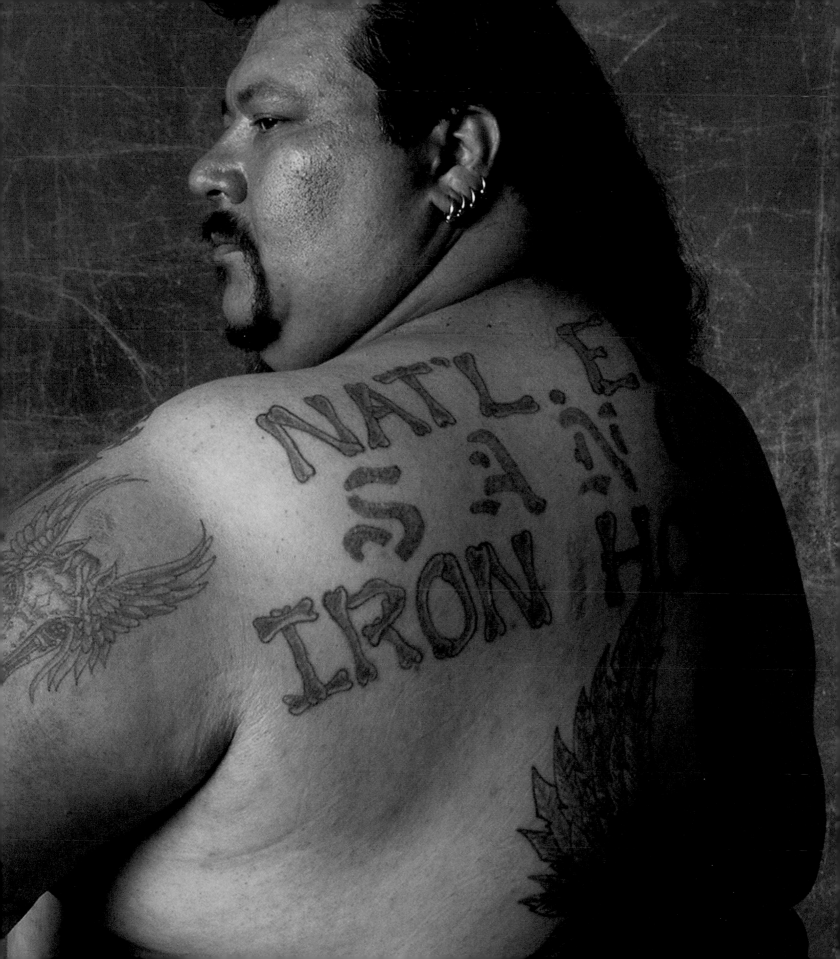

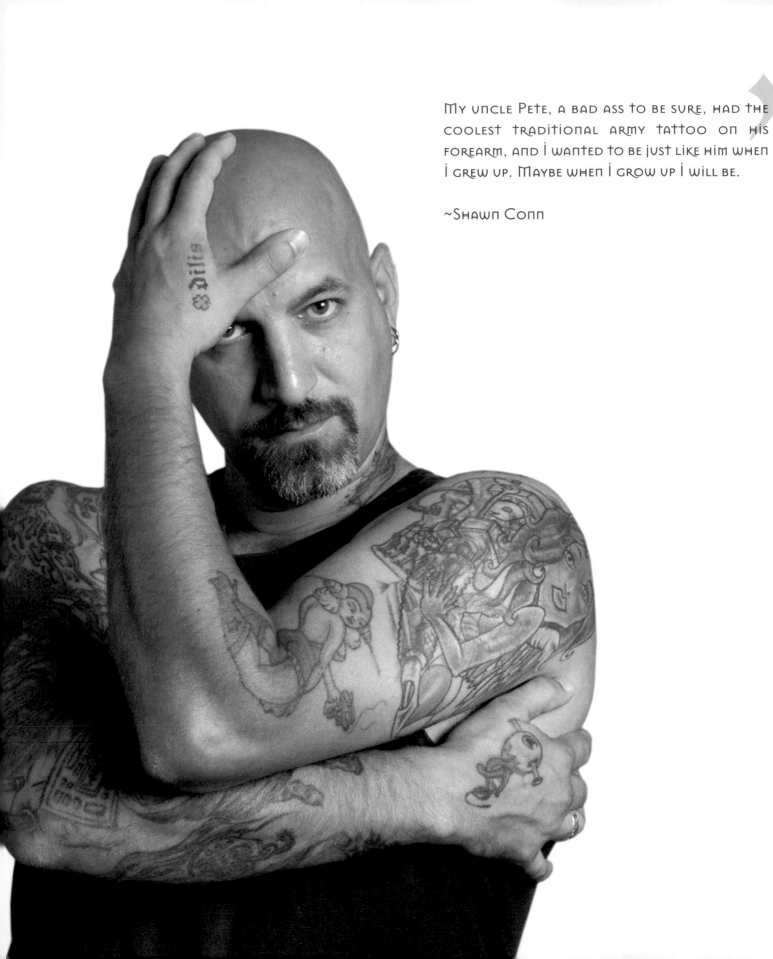

"My uncle Pete, a bad ass to be sure, had the coolest traditional army tattoo on his forearm, and I wanted to be just like him when I grew up. Maybe when I grow up I will be.

~Shawn Conn

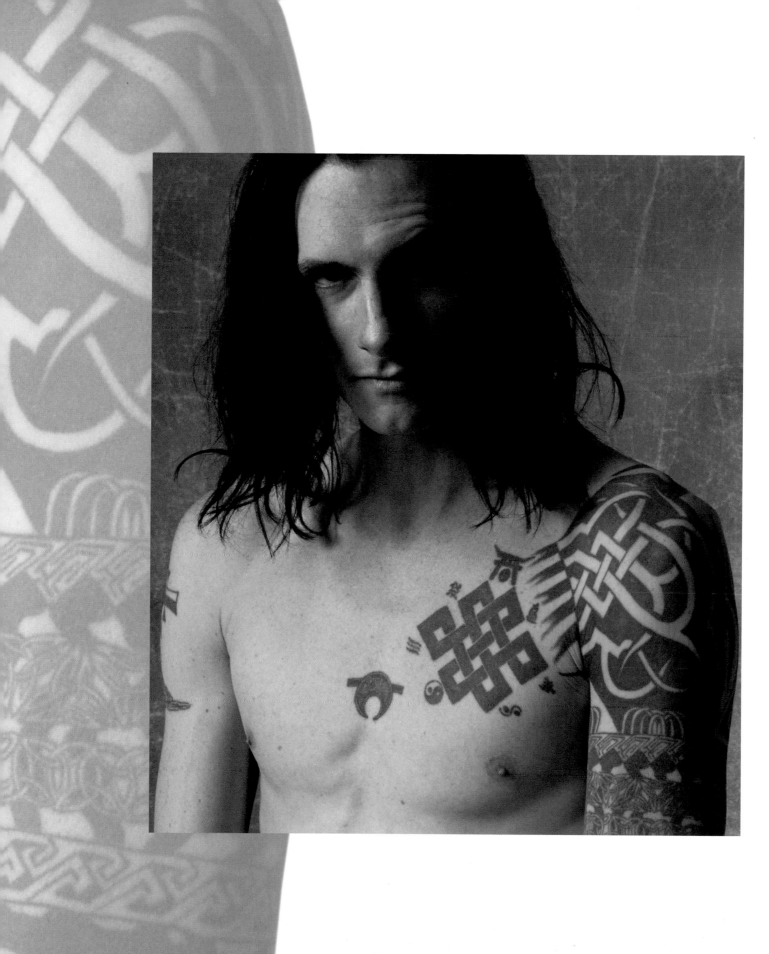

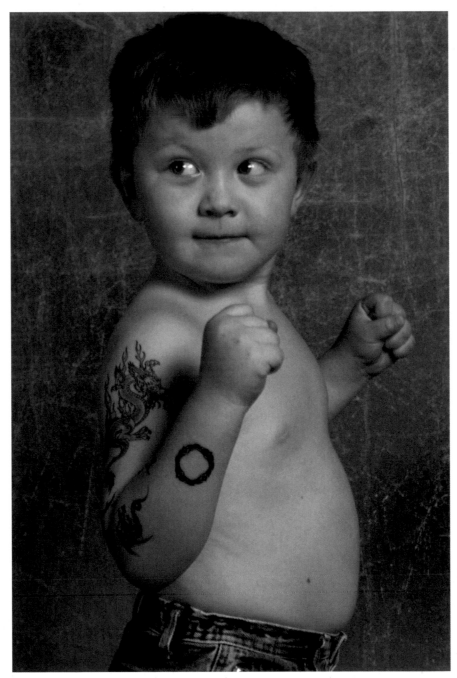

54

"I got my first tattoo, a design of a girl and a dog on my upper right arm. It had no particular meaning, I just liked the way it looked. I just wanted something that would attract attention, and the meaning would be left up to each person's interpretation.

~Colleen Tabolt

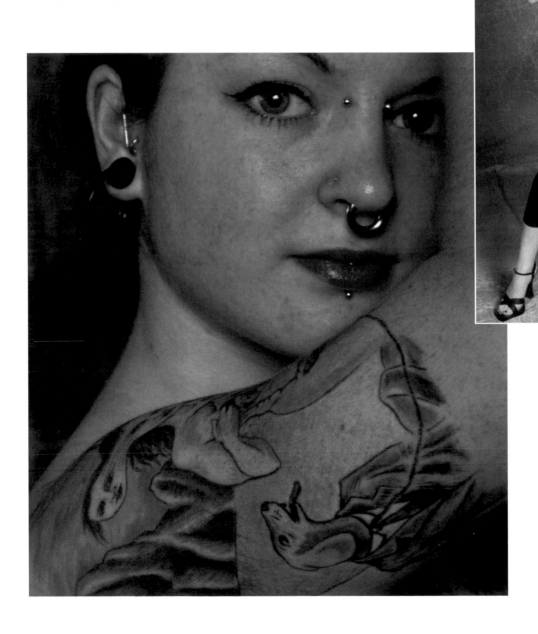

I RECEIVED MUCH OF MY TATTOO WORK IN PRISON. THE FIRST TATTOOS I GOT WERE USUALLY THE RESULT OF "BETTER LIVING THRU CHEMICALS," MY PRISON TATTOOS WERE THE RESULT OF THE BOREDOM ASSOCIATED WITH JAIL TIME.

~Matthew Mesiano

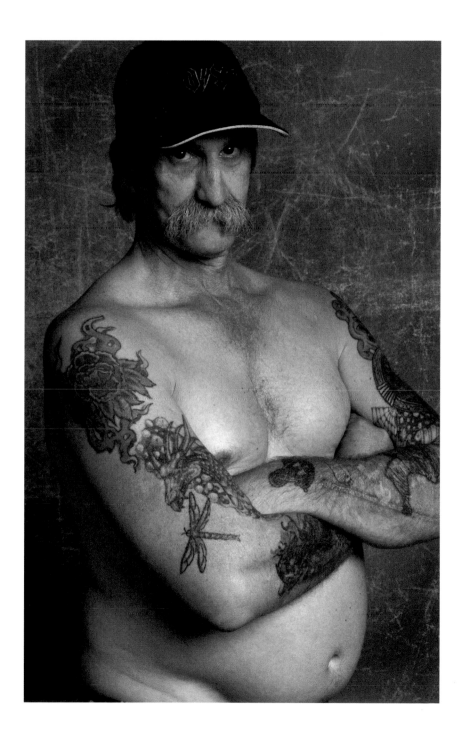

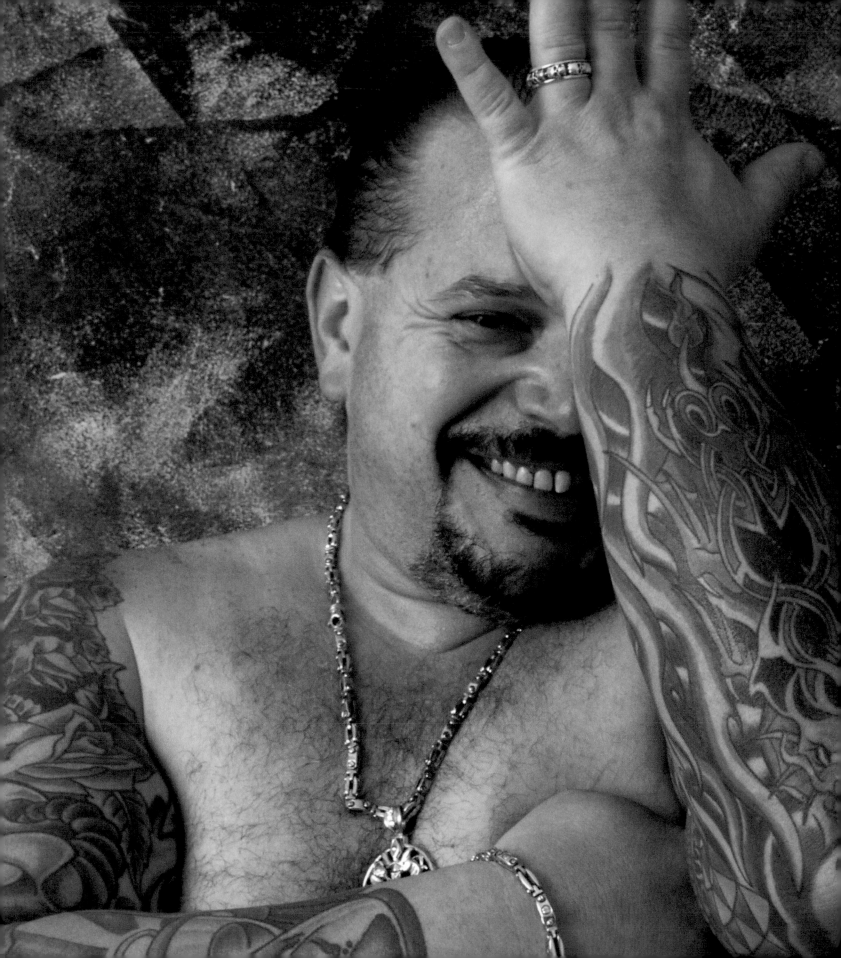

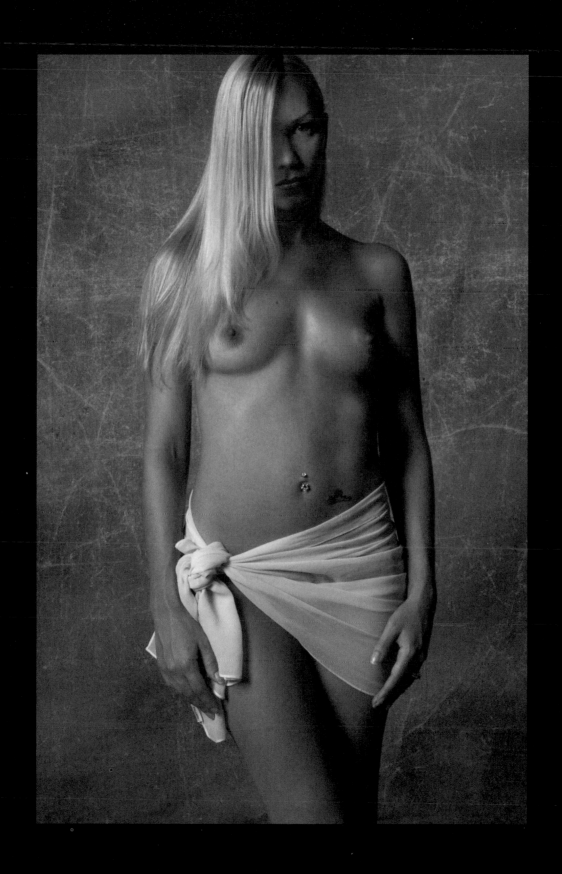

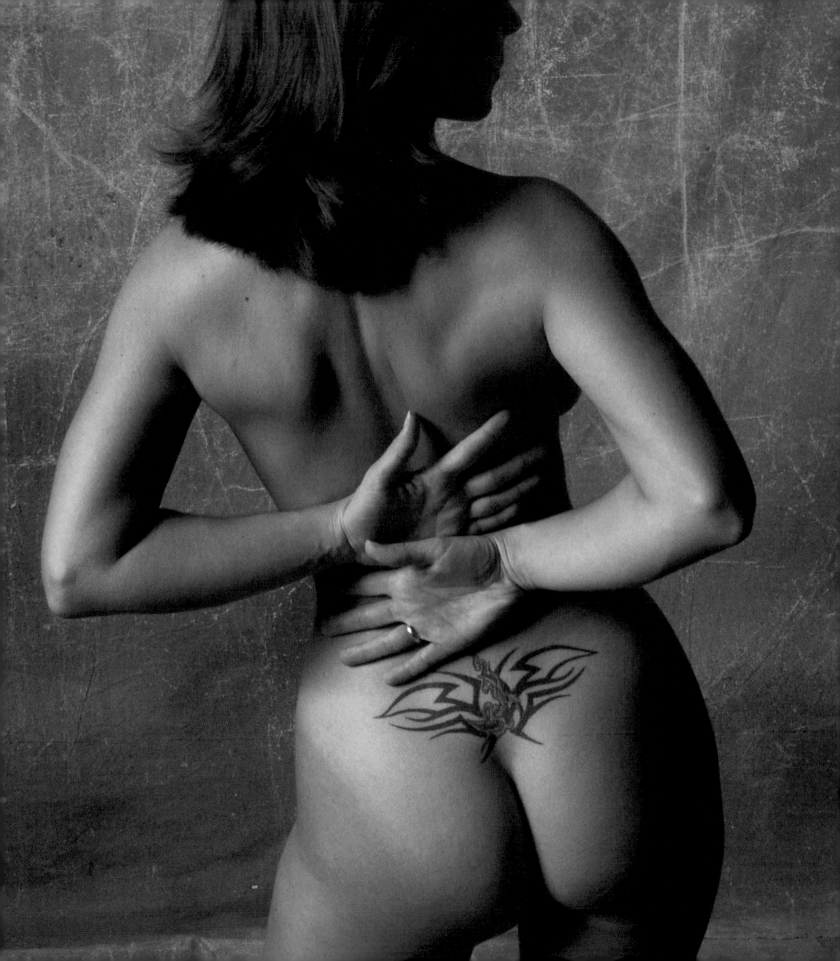

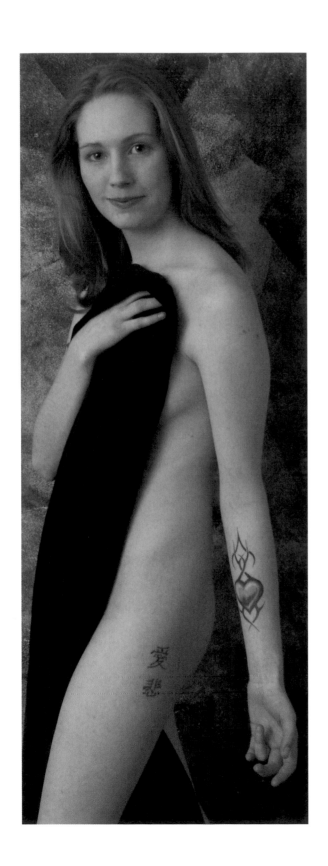

My Chinese symbols are for my dad and good friend who passed away. It means a great deal to me to have part of them with me. The humming bird and morning glory is me and my mom's thing.

~Denise McLaughlin

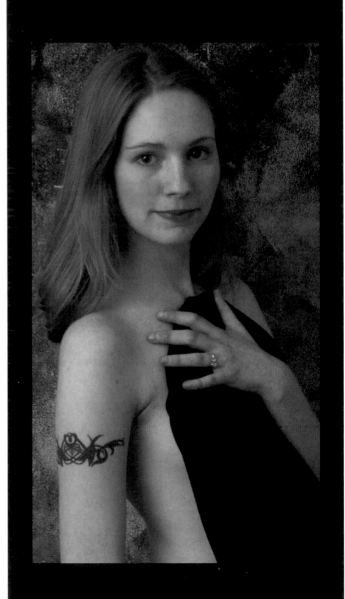

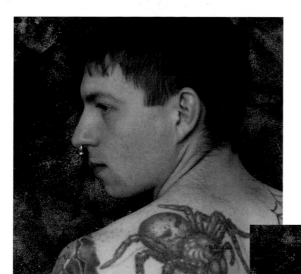

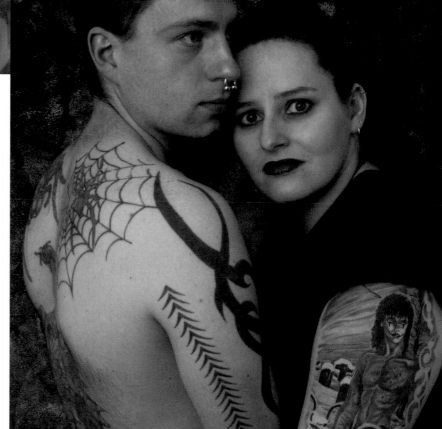

My first inspiration was my love of "the crow," by James O'Barr.

~Sharon Kamprath

I became a tattoo artist from my father teaching me at the age of 15. My first tattoo was to have a memory of something my father gave me that lasts a lifetime.

~Trevor Sibary

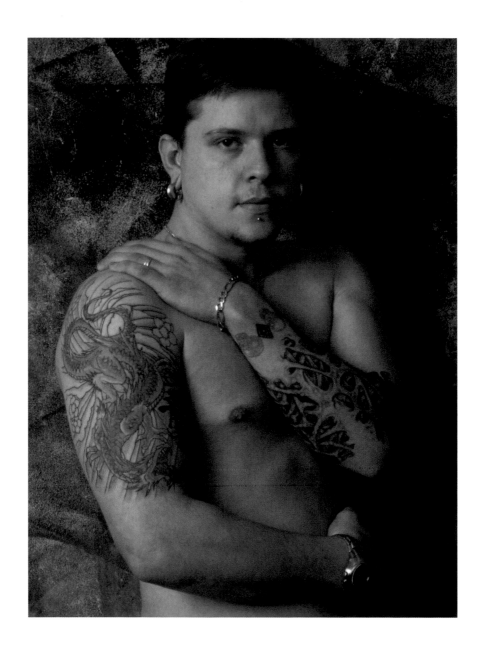

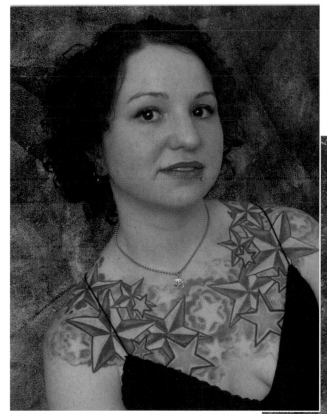

"Omigod, is that real?" — the worst.

~Christine Ostrander

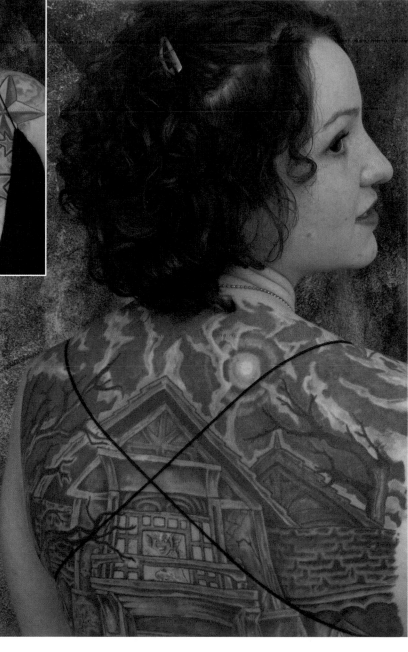

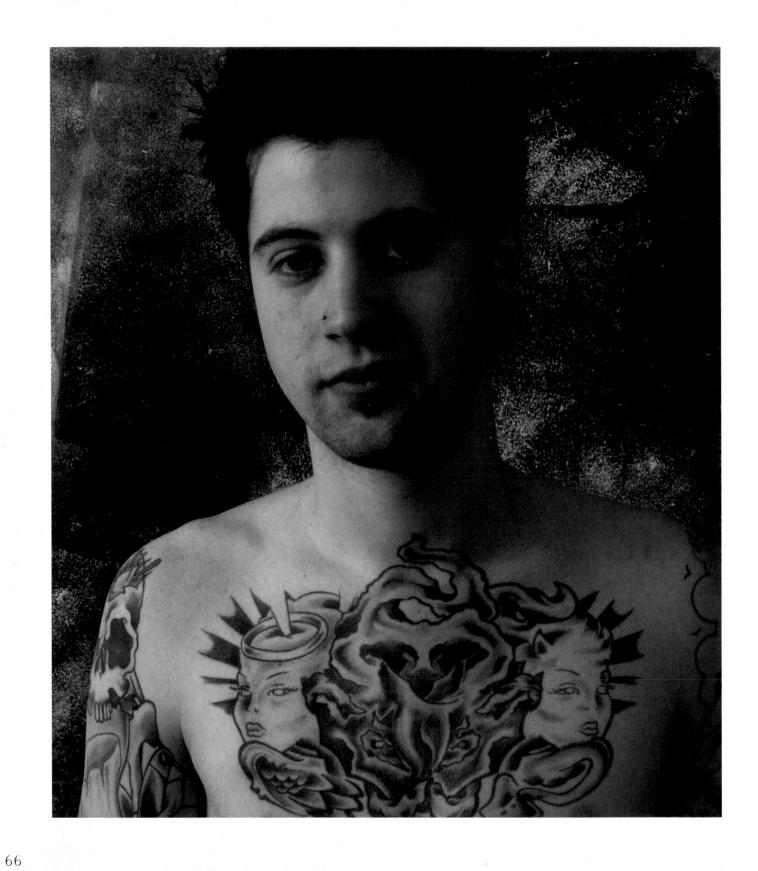

66

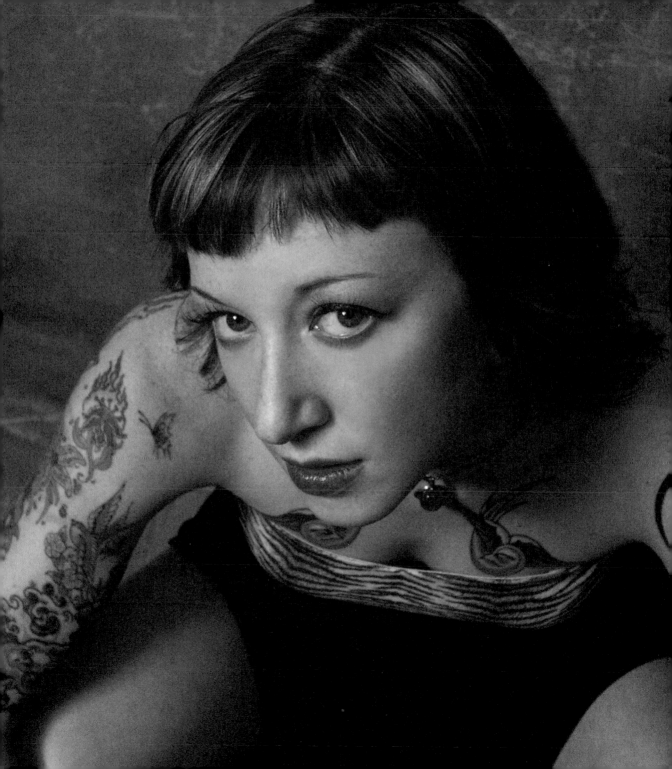

BECAUSE YOU WOULDN'T HAVE A NAKED CHRISTMAS TREE. "

~Joline Simonetta

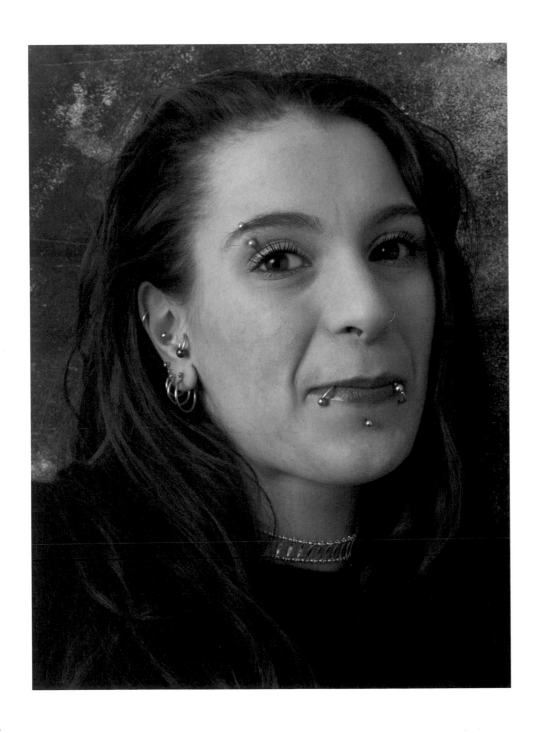

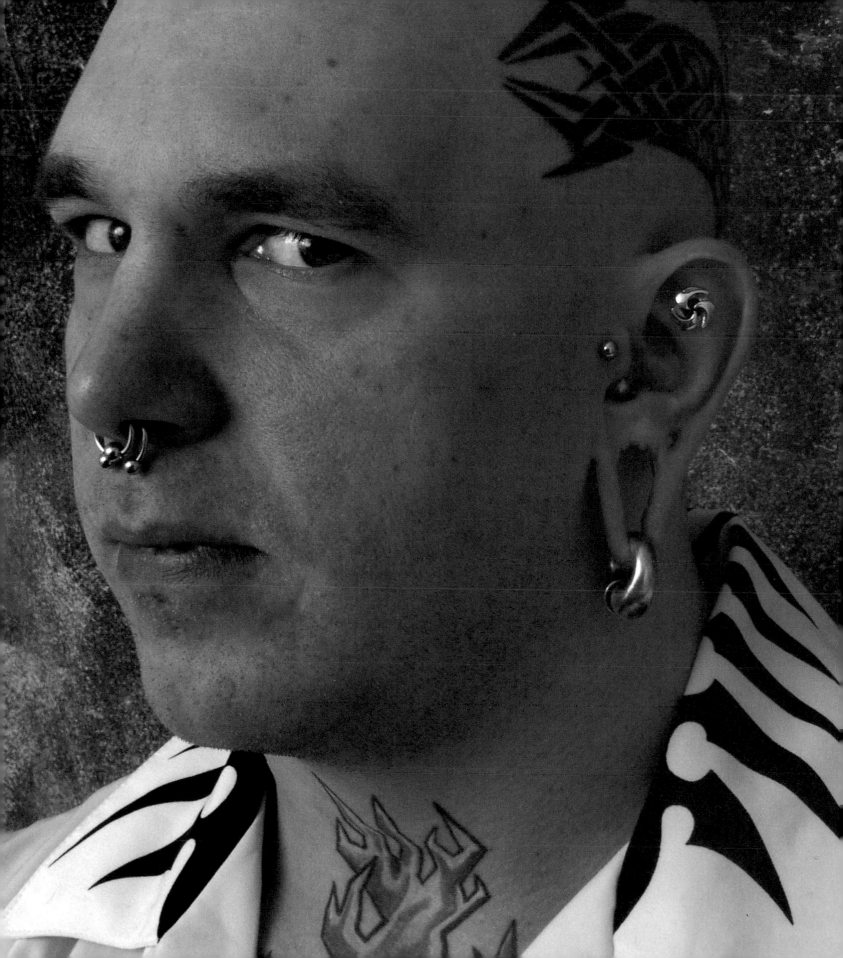

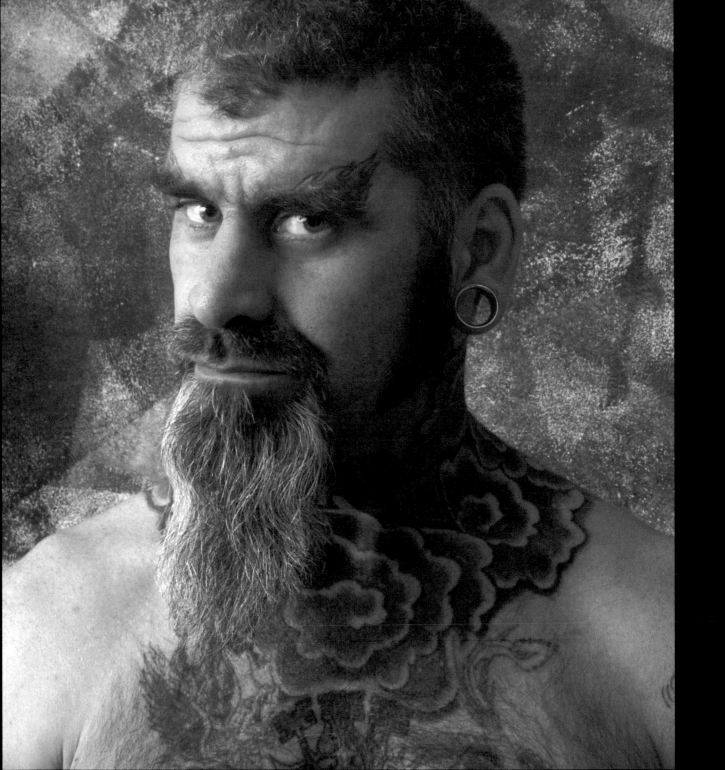

My body art was the transition from boyhood to manhood – just made it to the 82nd Airborne – and a strong urge to represent negative and positive energies through symbols for it is a part of me.

I have never heard "Oh, my God" so much in my life and now I think they're right!

It is not so much that I would want anyone to know about me as much as I would want them to know themselves and I know I AM.

~David Heydn

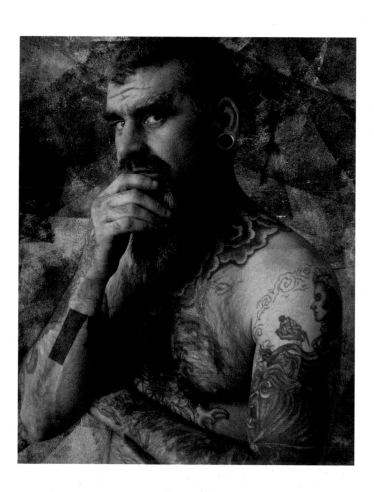

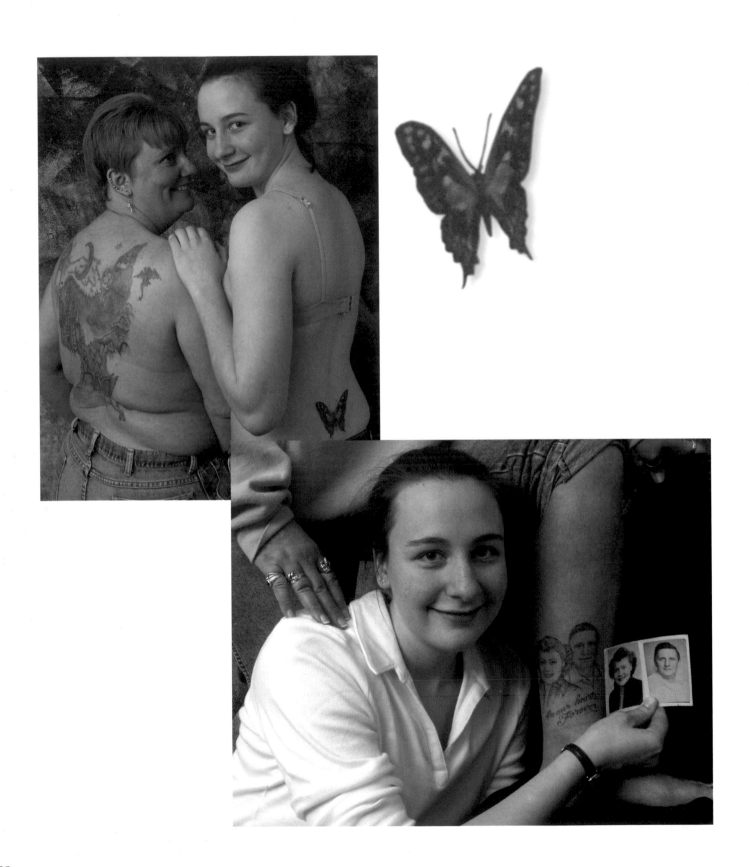

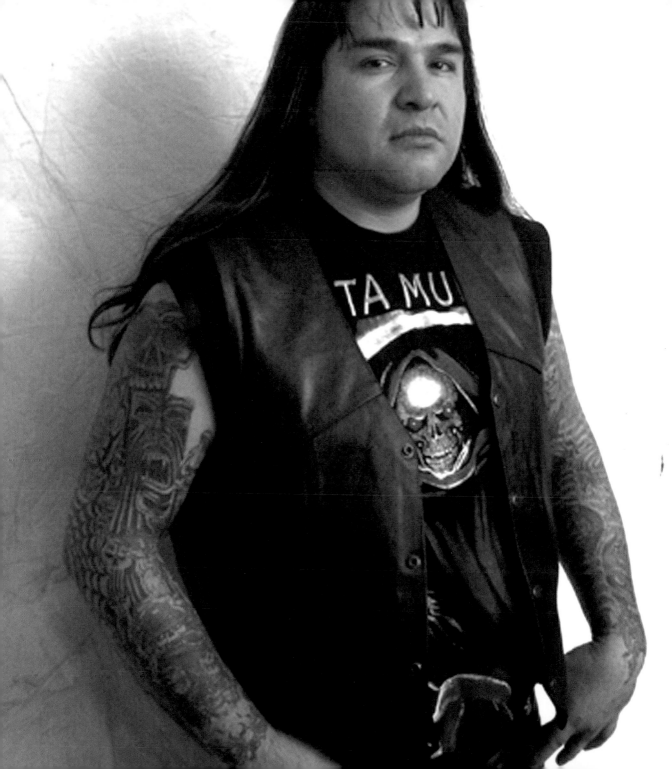

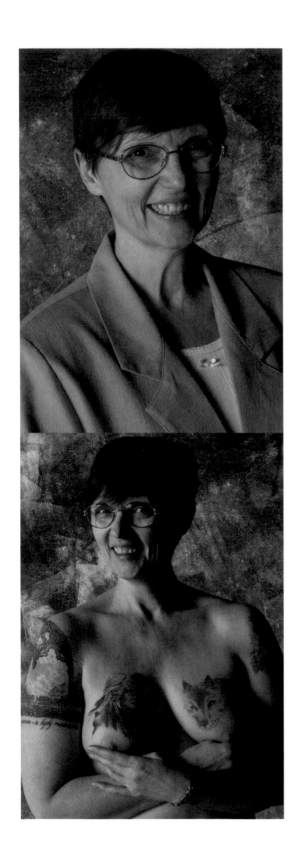

I'm just a plain, average person (with 17 tattoos). Single mom, two adult kids, 22 years at the same company in a logistics/purchasing job. The kind of person you see on the street every day.

I wanted one when I was 15 but decided to think about it for 32 years.

When it was time to get a tattoo, it apparently was also time to meet Tee Jay [my artist]. She's one of my heroes — and that's that.

~Gayle Cunningham

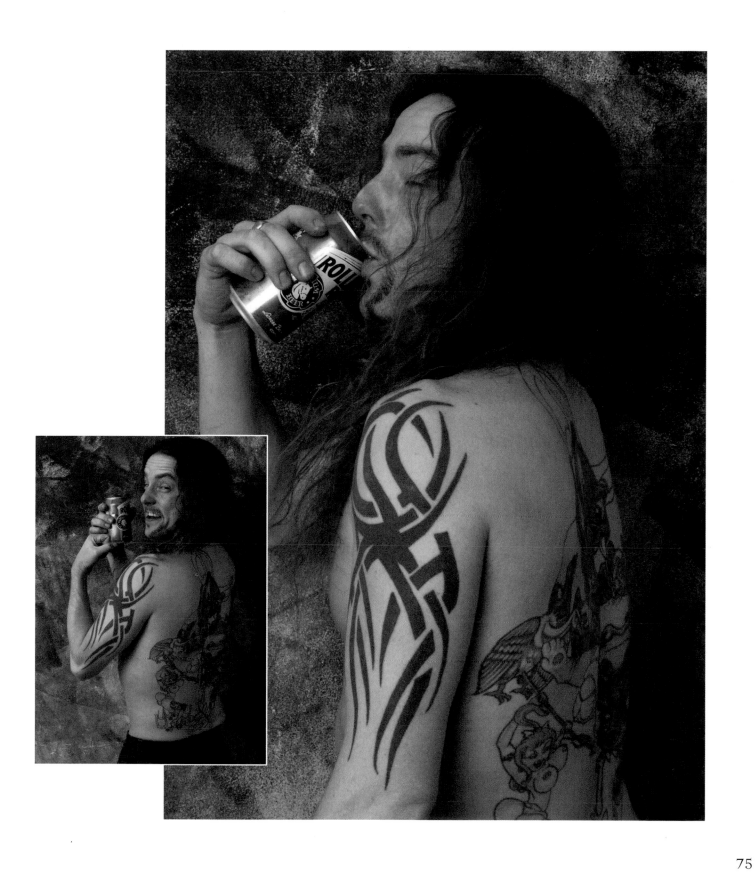

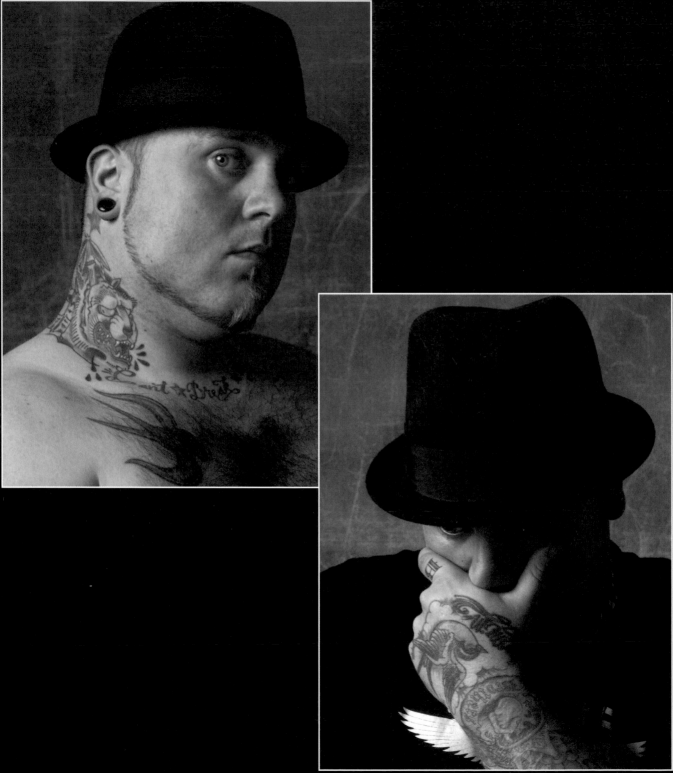

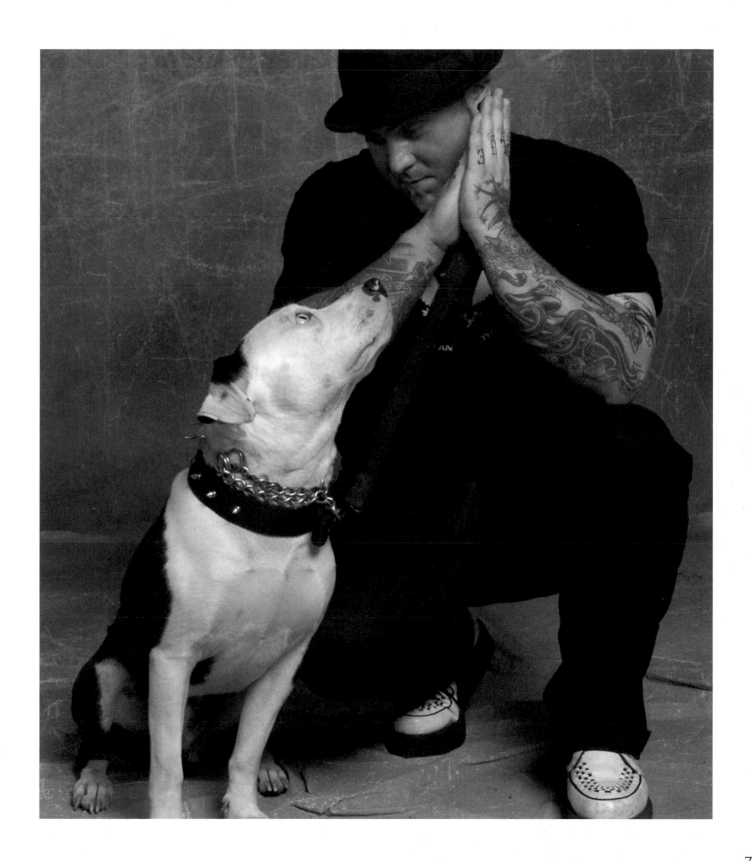

I personally don't care what other people think of my tattoos. They are about me, not them.

Don't sweat the small stuff.

~Clayton Eckerd

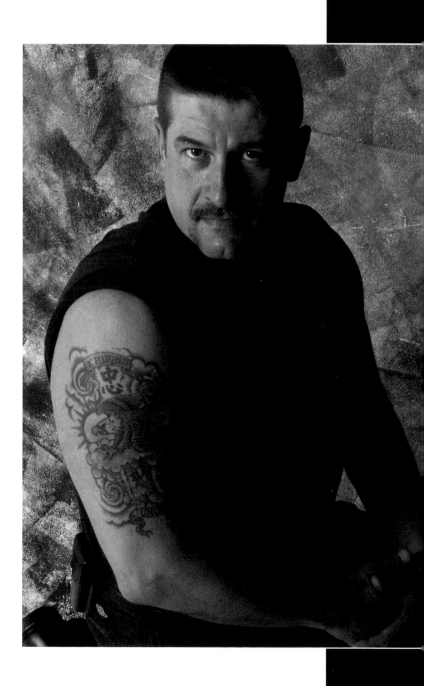

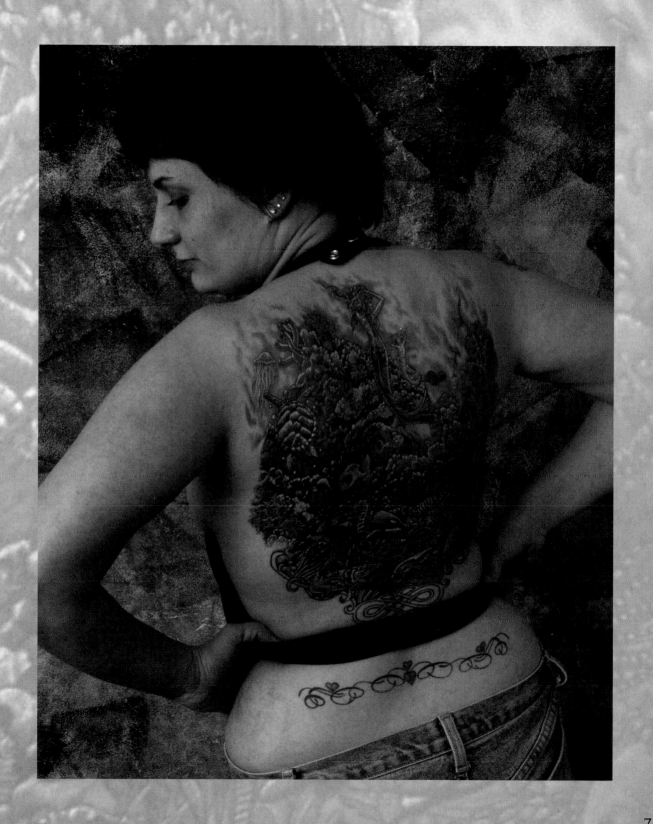

I HAD BILATERAL BREAST RECONSTRUCTION
AFTER BEING DIAGNOSED WITH CANCER AT THE
AGE OF 38.

WHEN FAMILY AND FRIENDS DISCOVERED MY
NIPPLES WERE TATTOOED, THEY WERE VERY
SURPRISED AND INFATUATED.

~DONNA ROSS

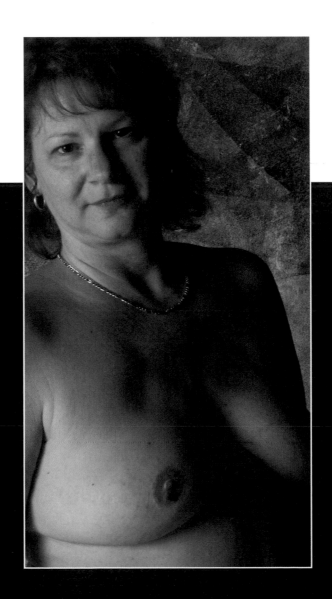

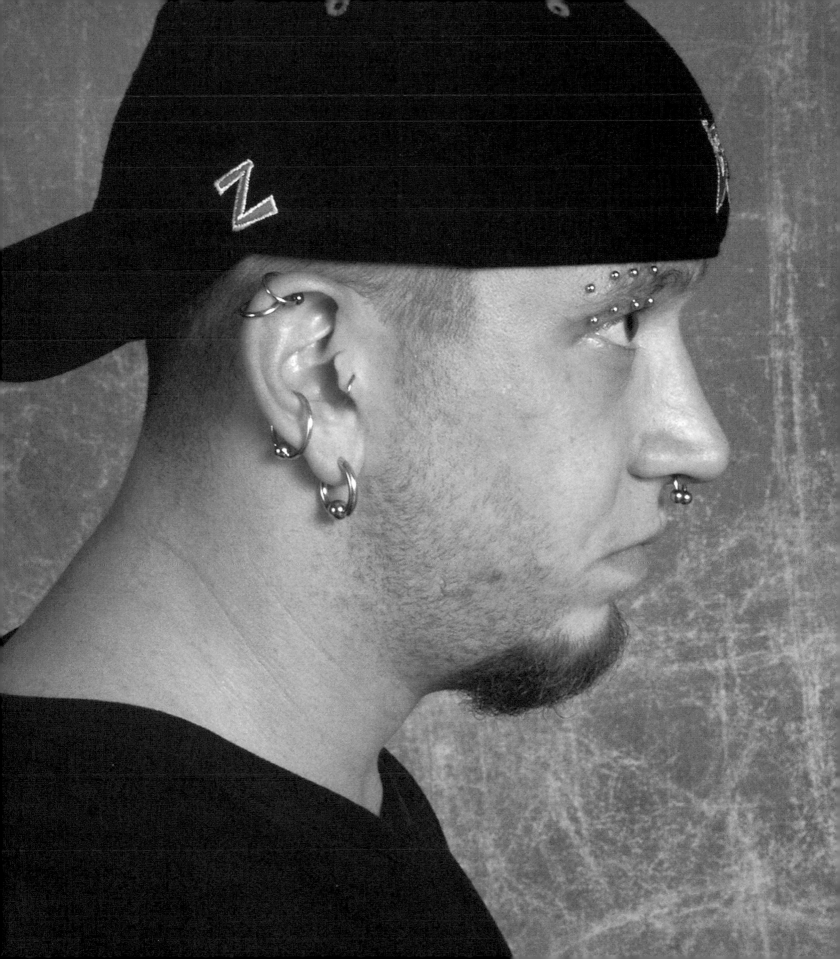

I am an artist trying to survive in such a large colorful world, and the need to take something to the grave with me. Each tattoo or piercing reveals a painful or joyous part of my life.

~Mike Bauer

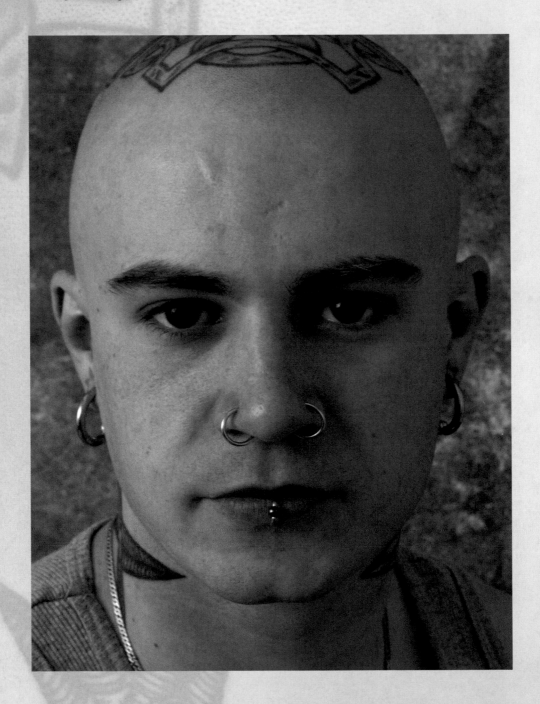

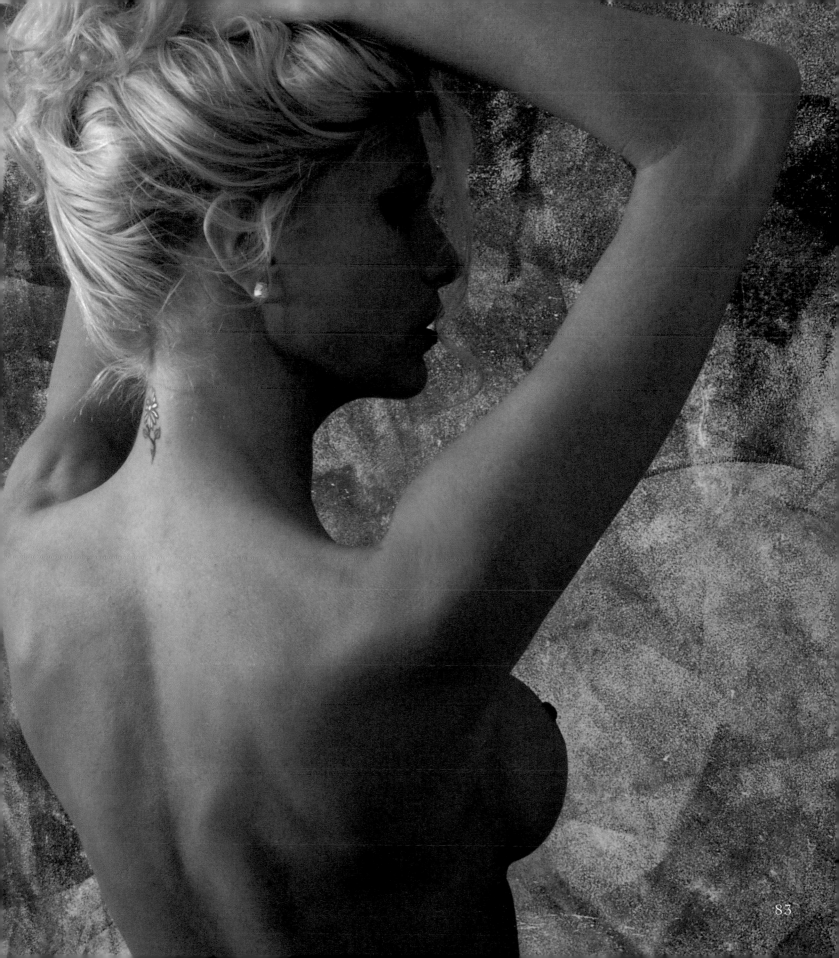

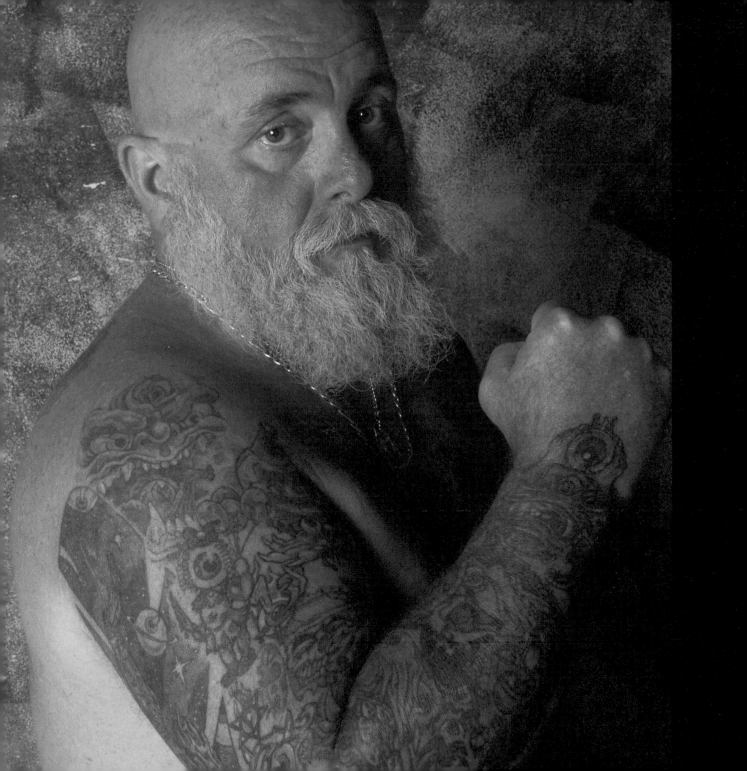

My first tattoo was a tribute to my father, who was killed suddenly when I was 10. The phrase "Live everyday like I'm sitting on your shoulder" will now stay with me forever.

~John Nelson

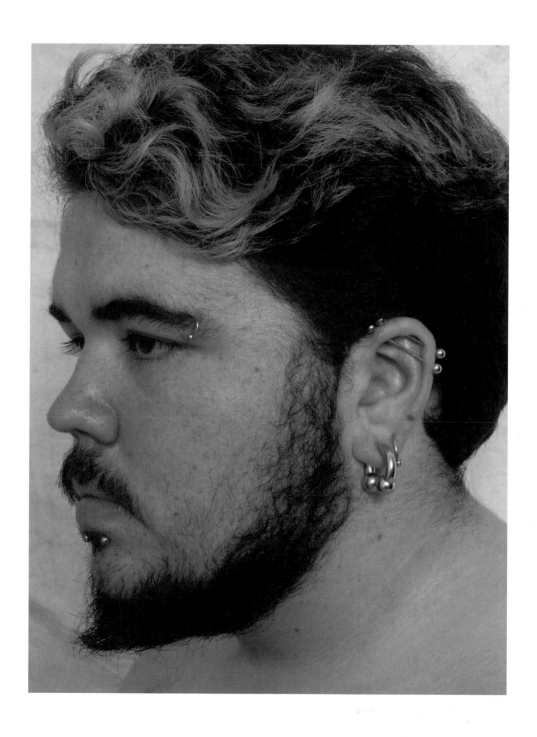

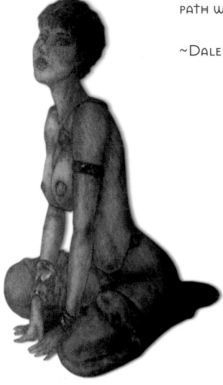

“The love of my life was the inspiration for my first tattoo. It marks the path we travel together.

~Dale Tucker

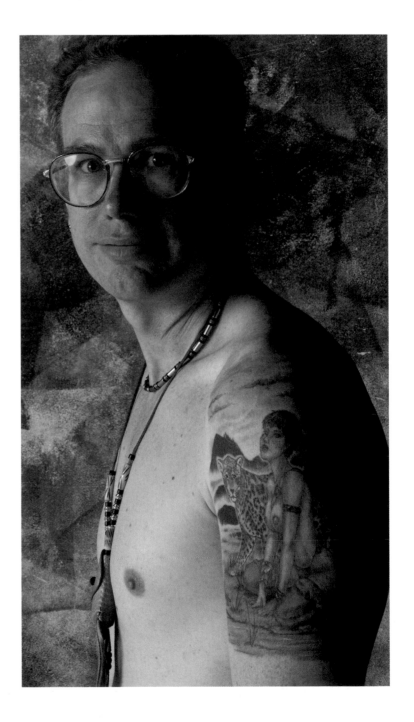

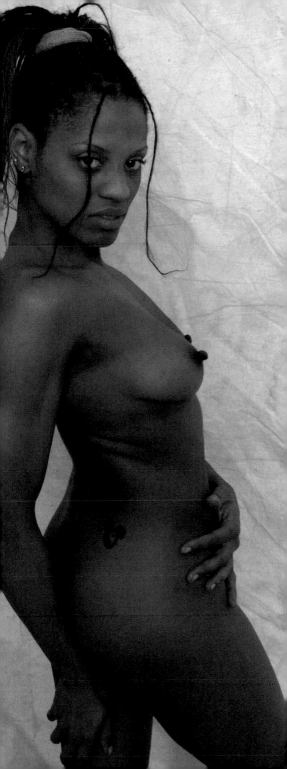

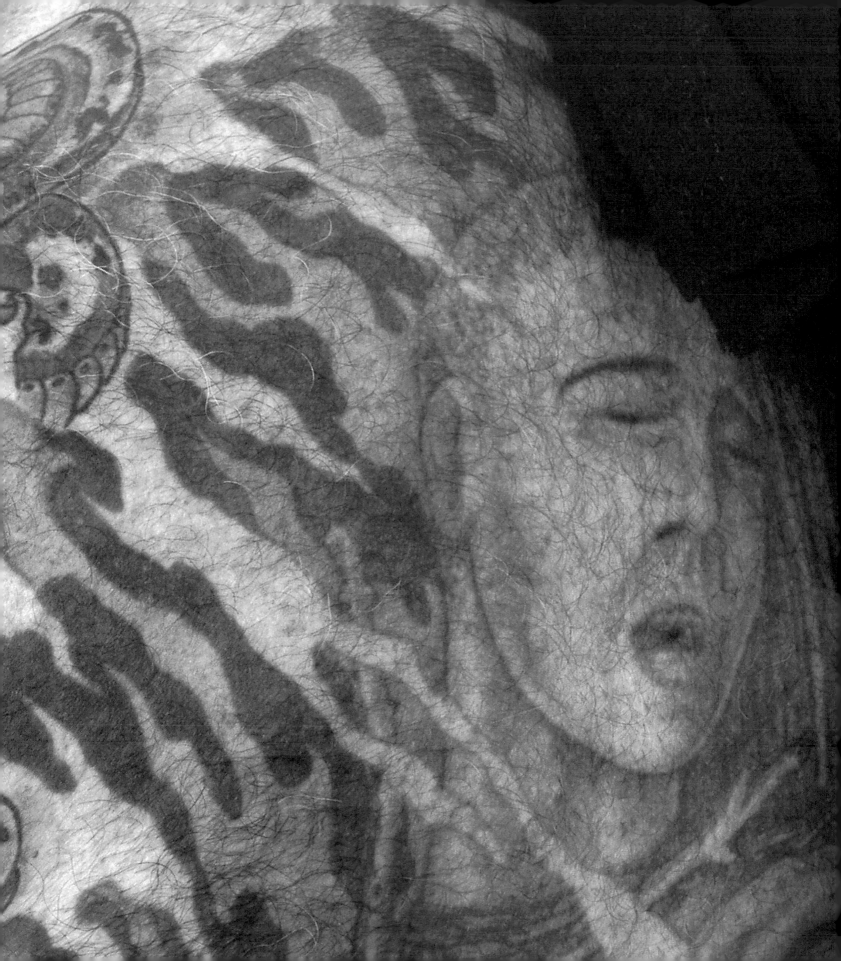

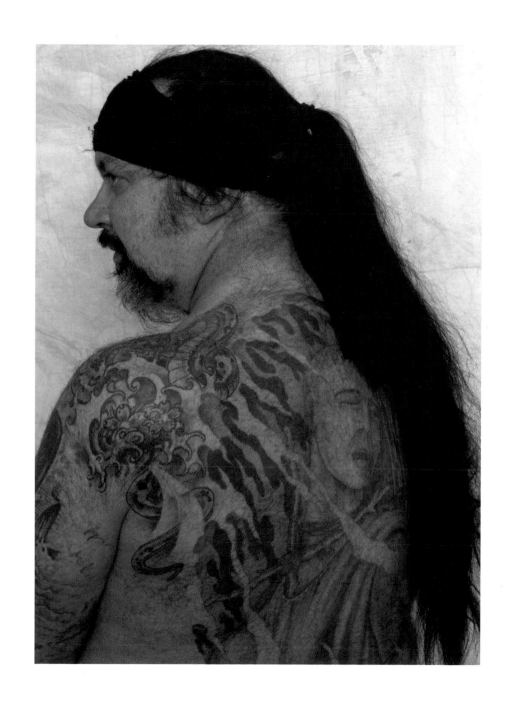

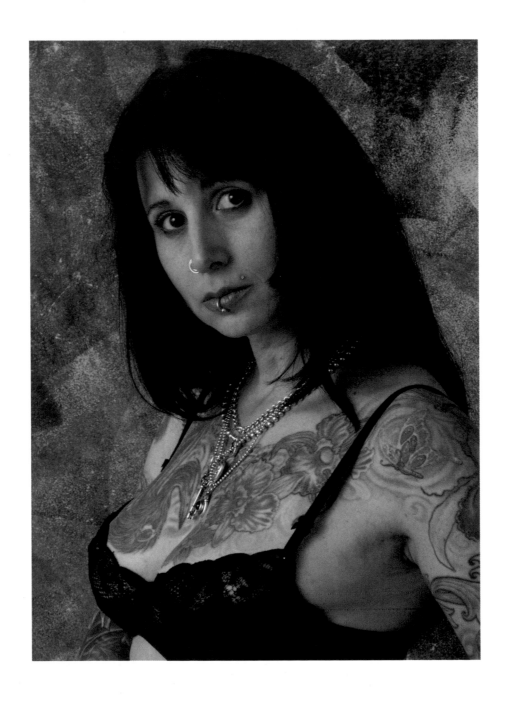

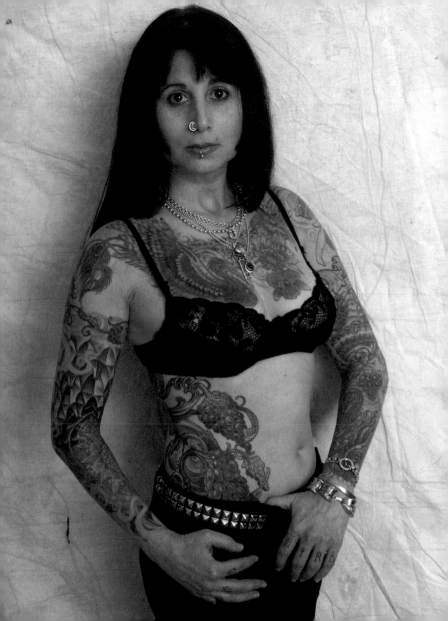

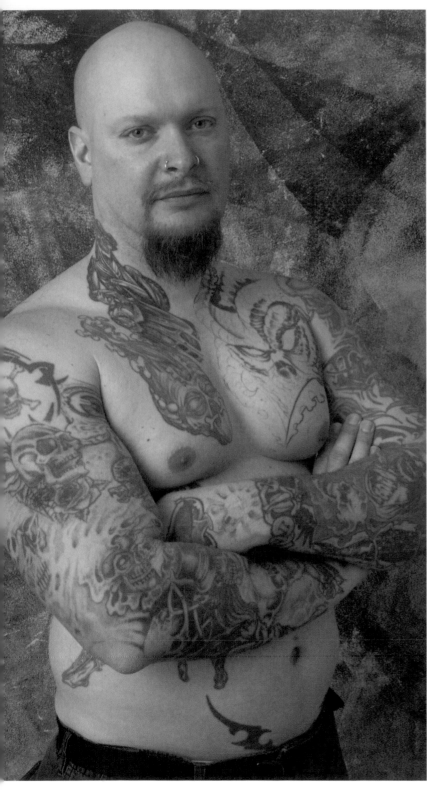
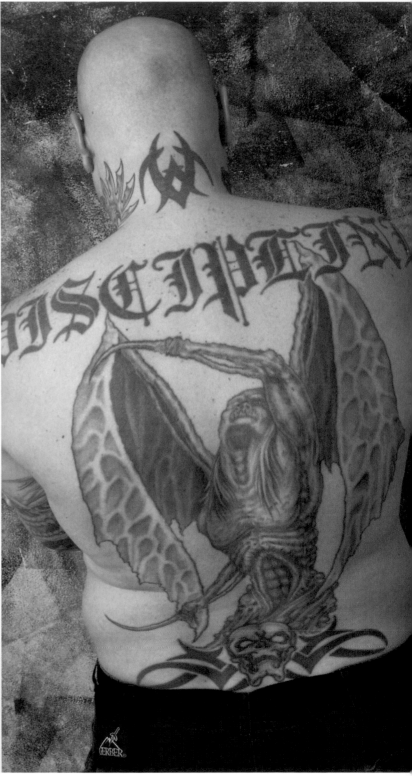

Being an artist, I've been inspired by art my whole life, now it is just visible to others.

~Maria Modafferi

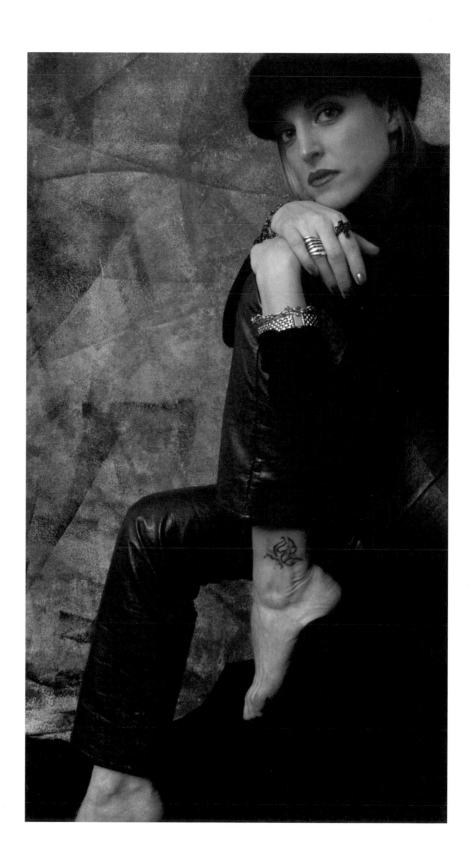

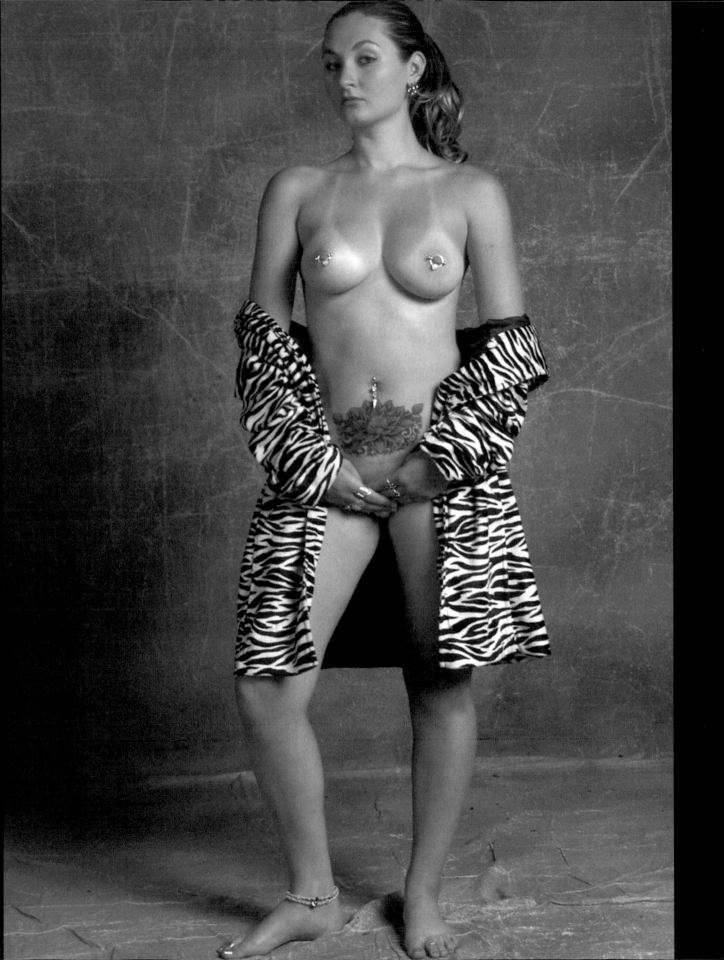

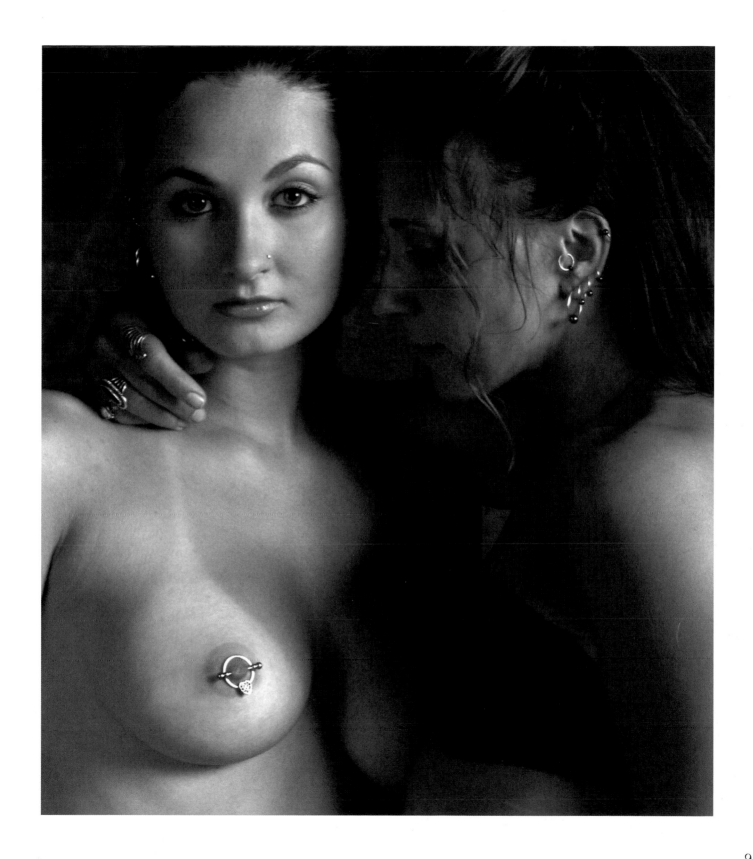

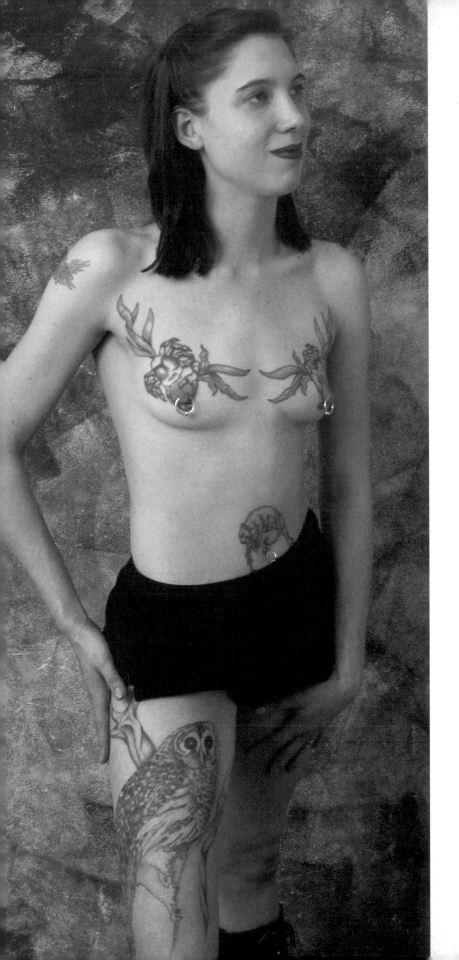

Every tattoo has a direct meaning — a symbol of something — a moment in time I didn't want to ever forget. Each is very special for me to look at and show.

~A.C. Nemec

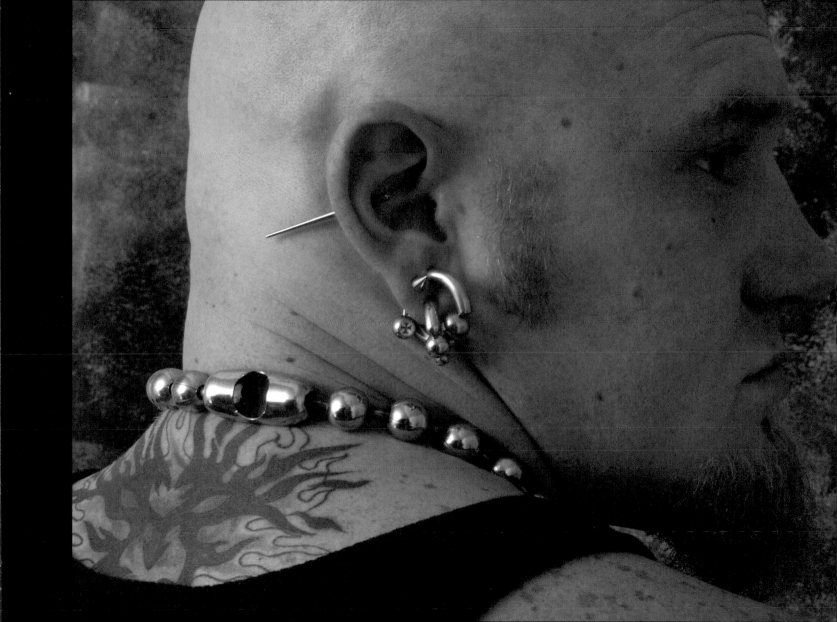

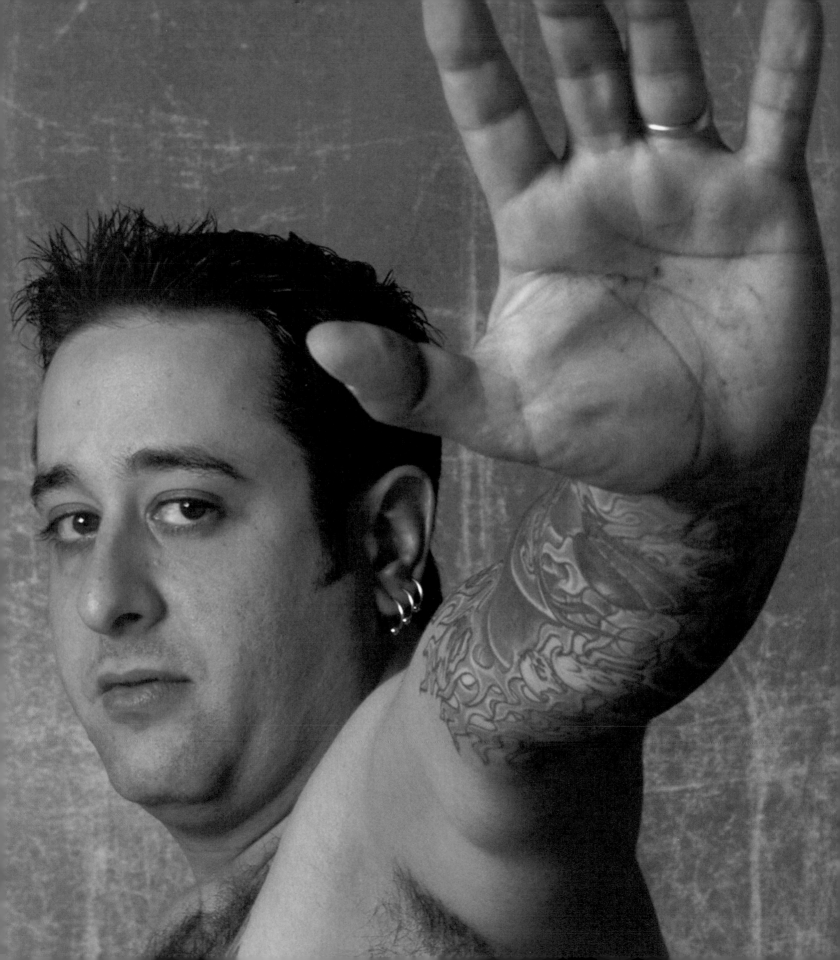

I have wings tattooed on my head. I've always wanted to fly.

An 80 year old doctor, during my physical, suggested I see a psychiatrist regarding my piercing and tattoos.

~Sarah Gravino

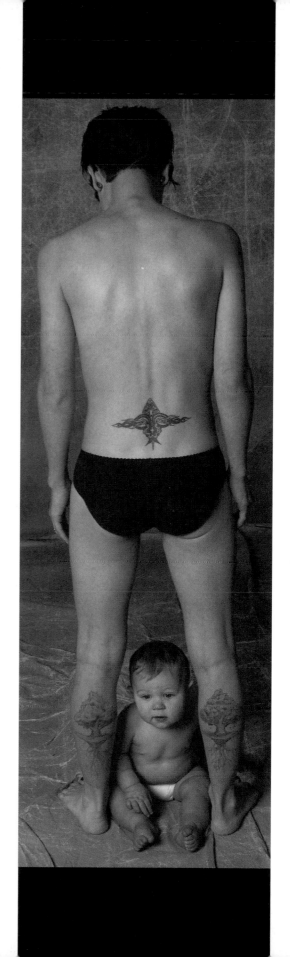

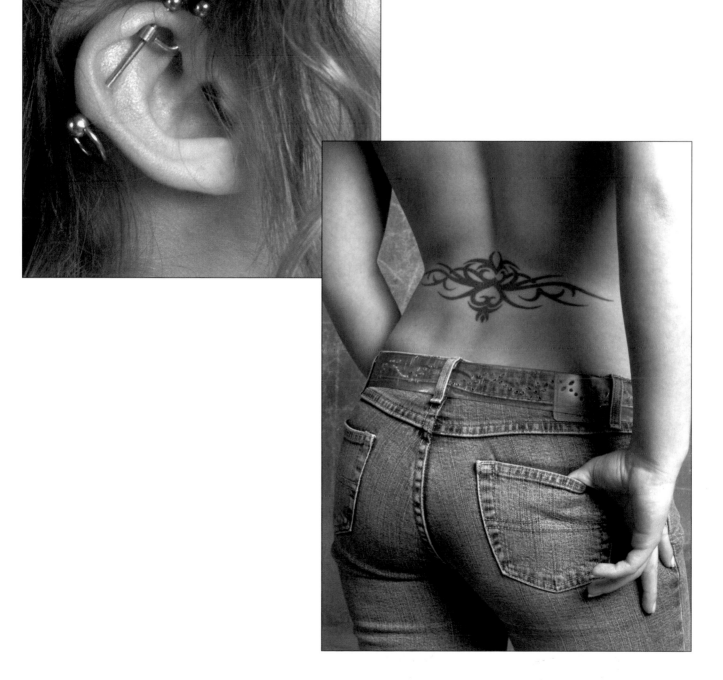

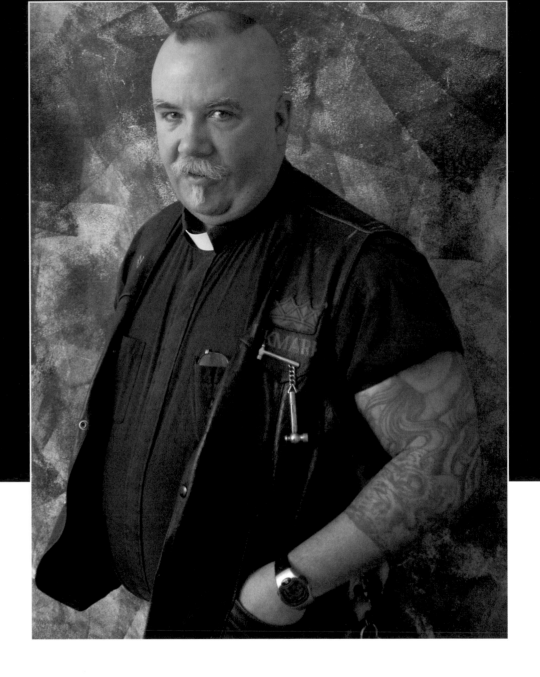

Since I saw my first tattoo it spoke to me. I got my first in the late 60's and have collected ever since. I have work in memory of lost brothers, events, my wife & the motorcycle world in general.

I have history in motorcycle clubs and found the savior in my travels. I worked for many years toward getting ordained as a minister. I had a church in a biker bar for 3 years. I am President of Melchizedeks MC which is taken from Scripture (Heb 7:17). The club has a 20 year history, I have been President for 3 years. We travel in the world of Motorcycle Clubs and carry the word. We ride, we camp, we live this life.

~Rev. Mark Catin

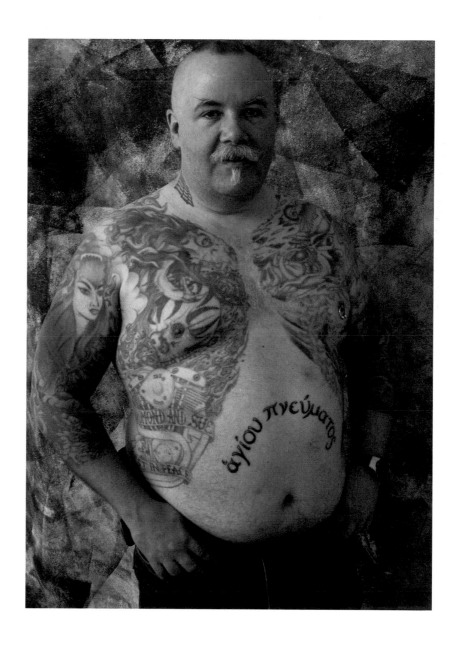

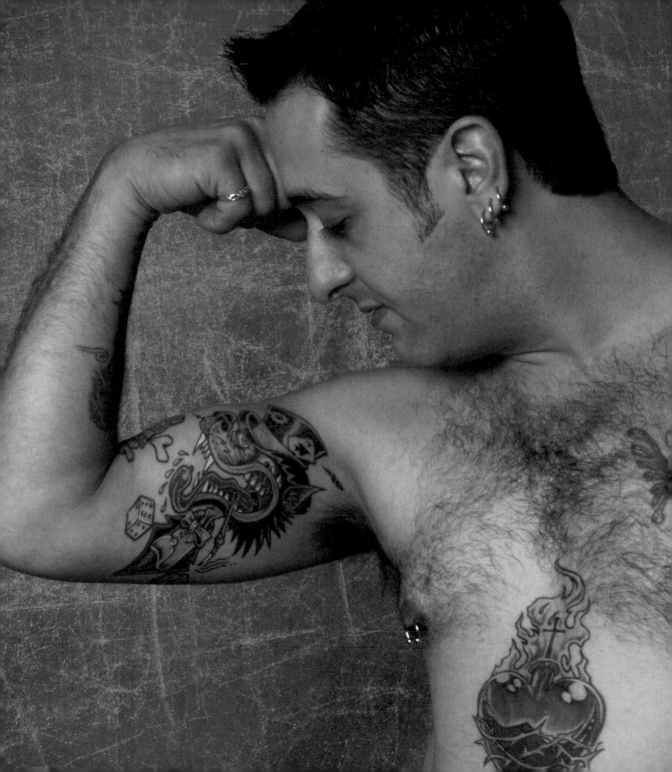

My tattoos are very personal to and for me.
I don't get them for others.

~Jon Poulakis

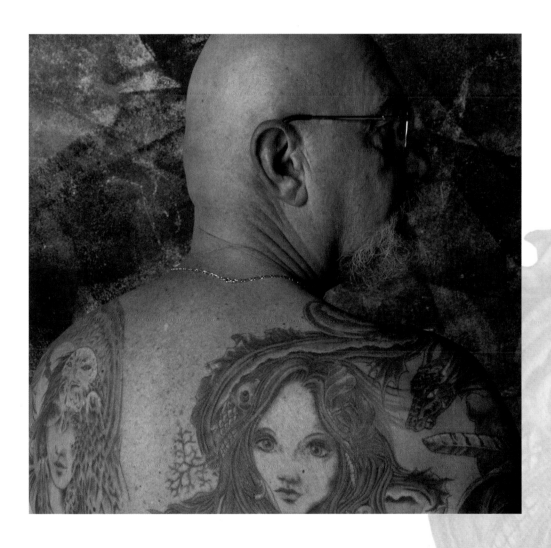

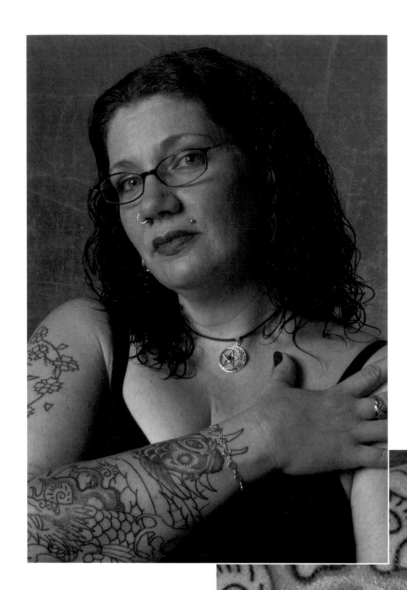

I got my first tattoo when I was 28 and my younger brother was turning 18. It was a birthday present for him, really, but we'd always been very close and wanted to get something the same, as a symbol of our bond. It's funny, because the artist I got did a really crappy job on mine, but his artist was great – it definitely didn't turn me off to tattoos, I've gotten lots more. But I would say that it's the only bad tattoo I have, and I'd still never get it covered up.

~Bonnie Harter

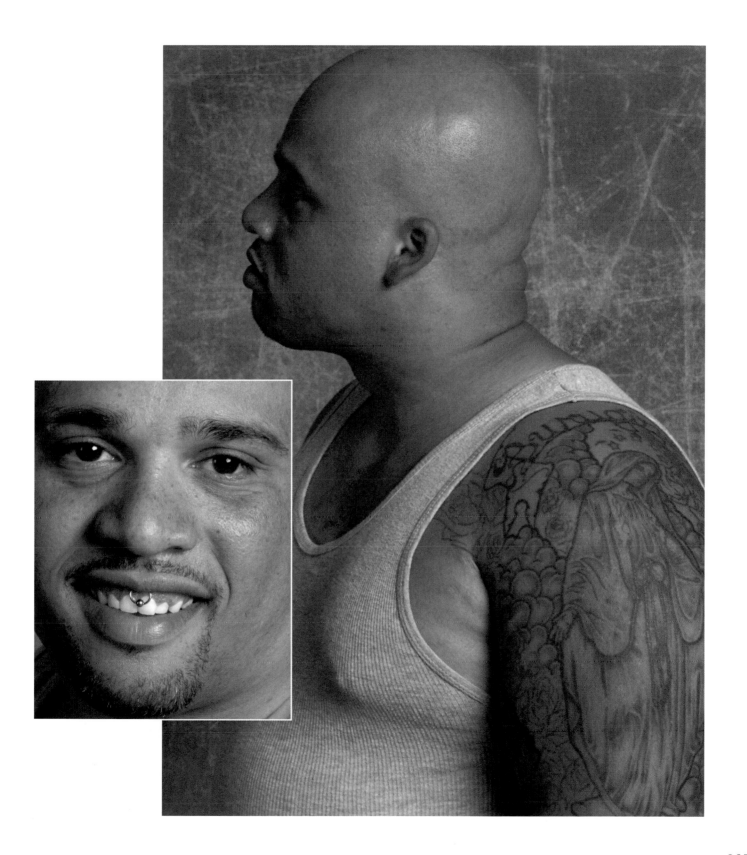

107

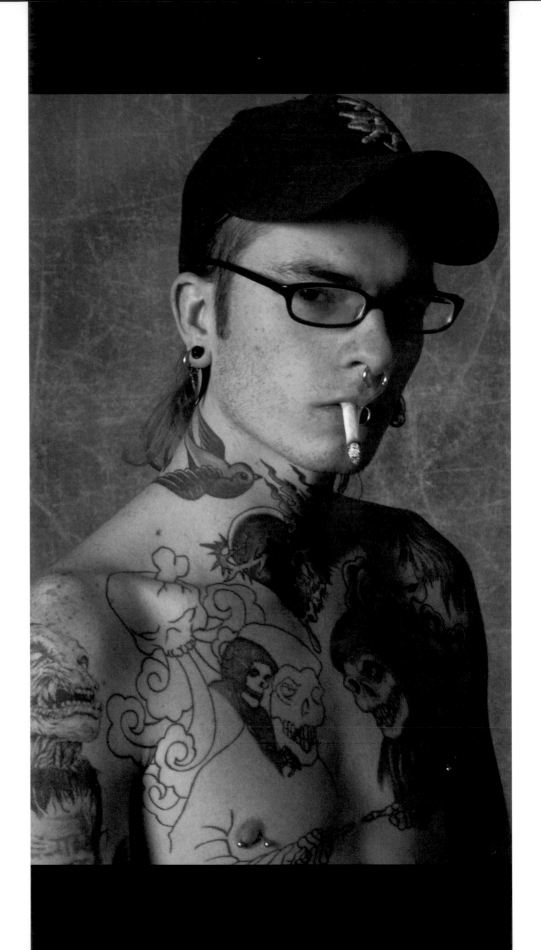

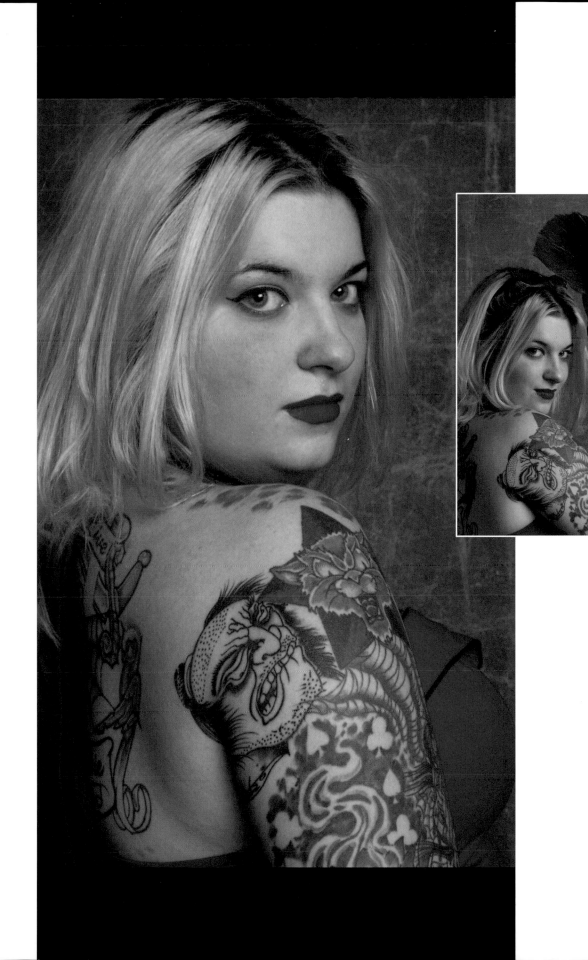

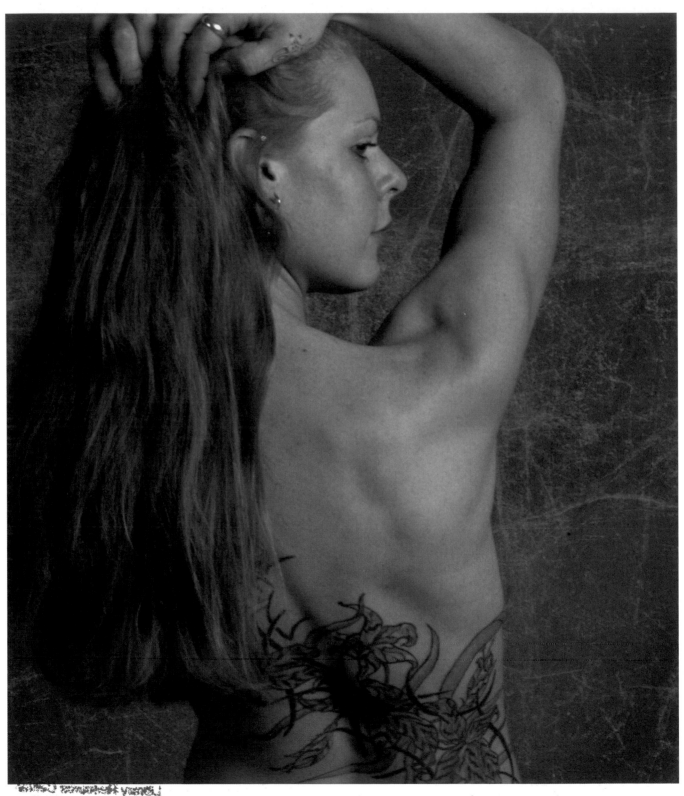

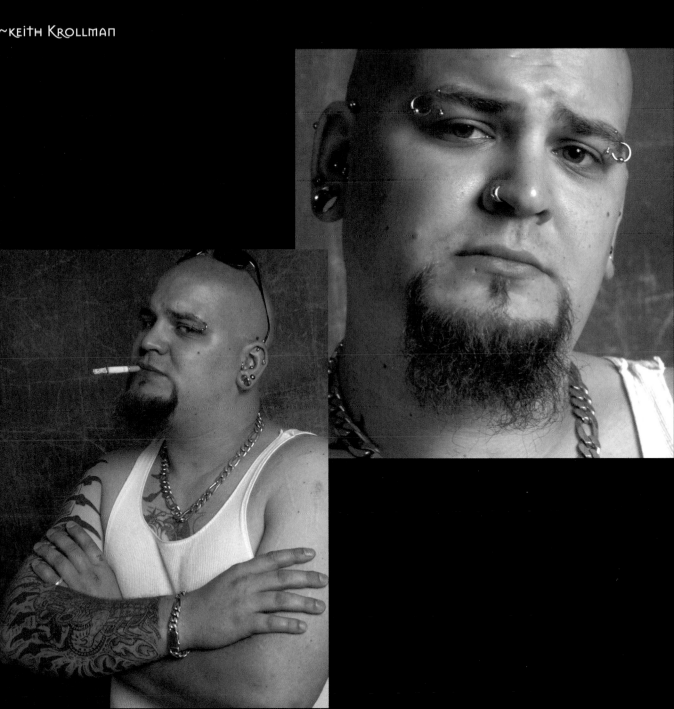

At age 15 I walked into a tattoo shop and in 10 minutes picked out a tattoo. I walked out with a tribal tattoo from my ankle to my knee.

~Keith Krollman

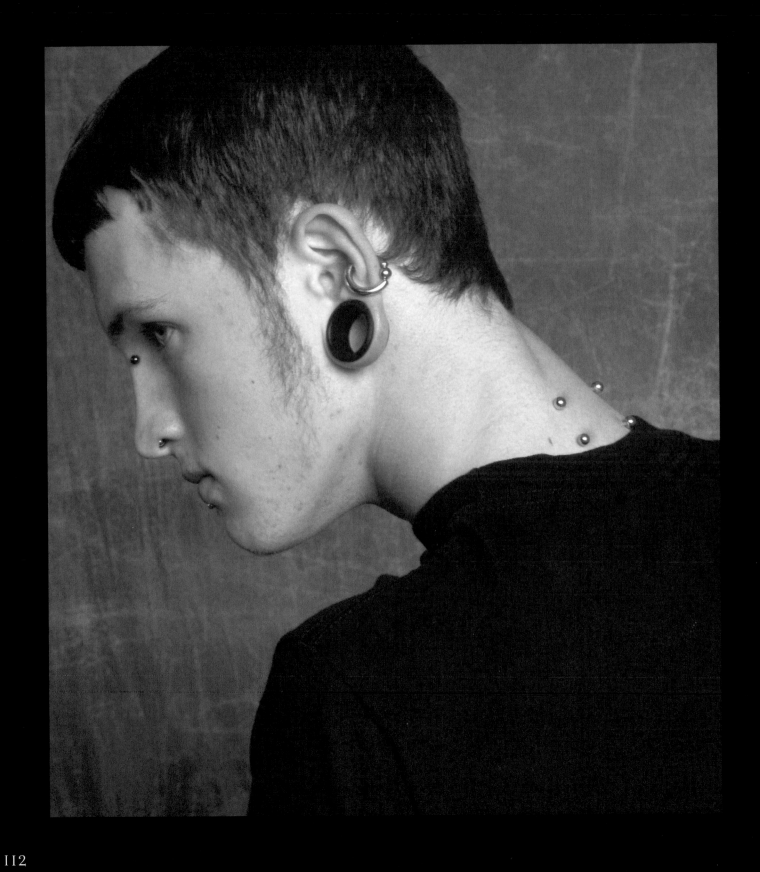

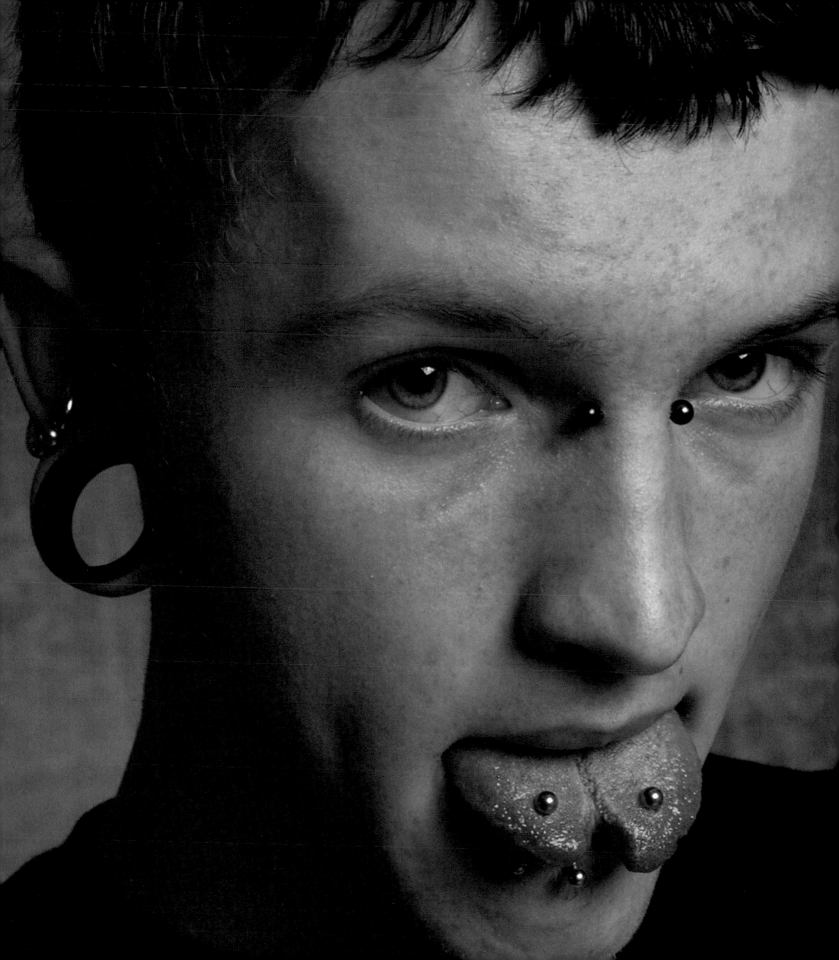

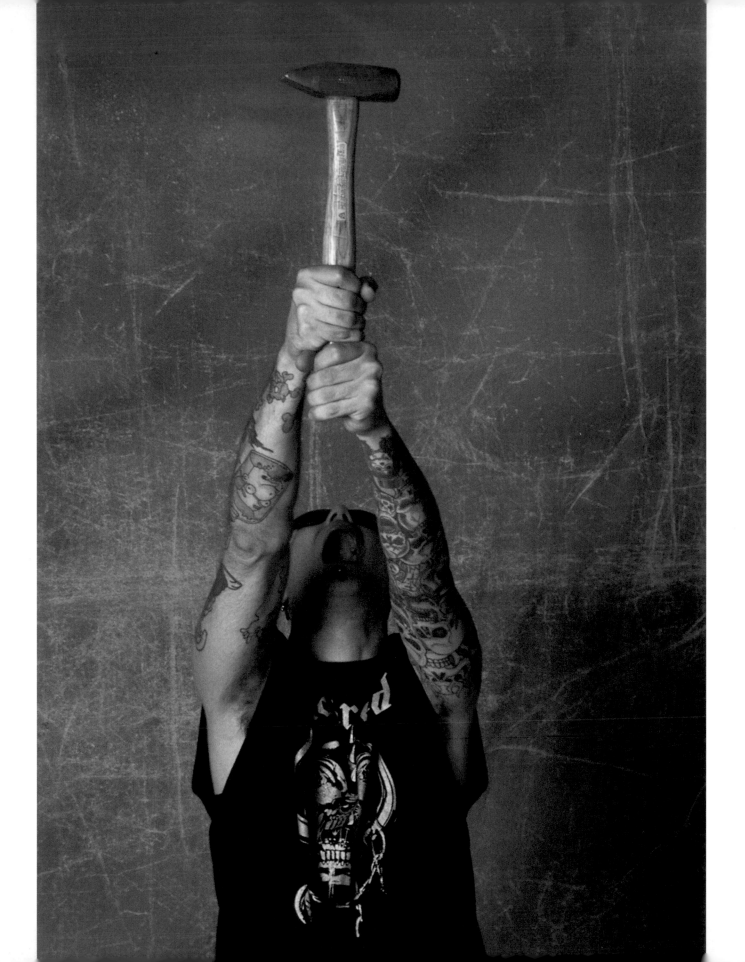

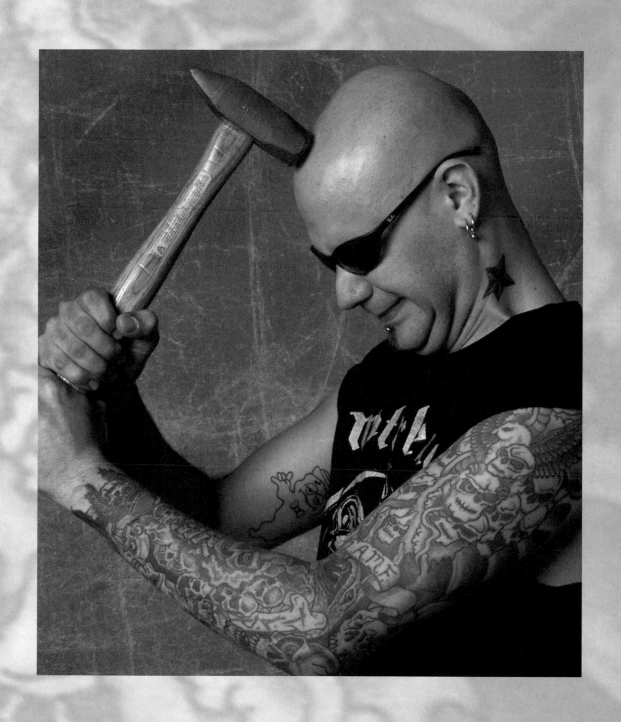

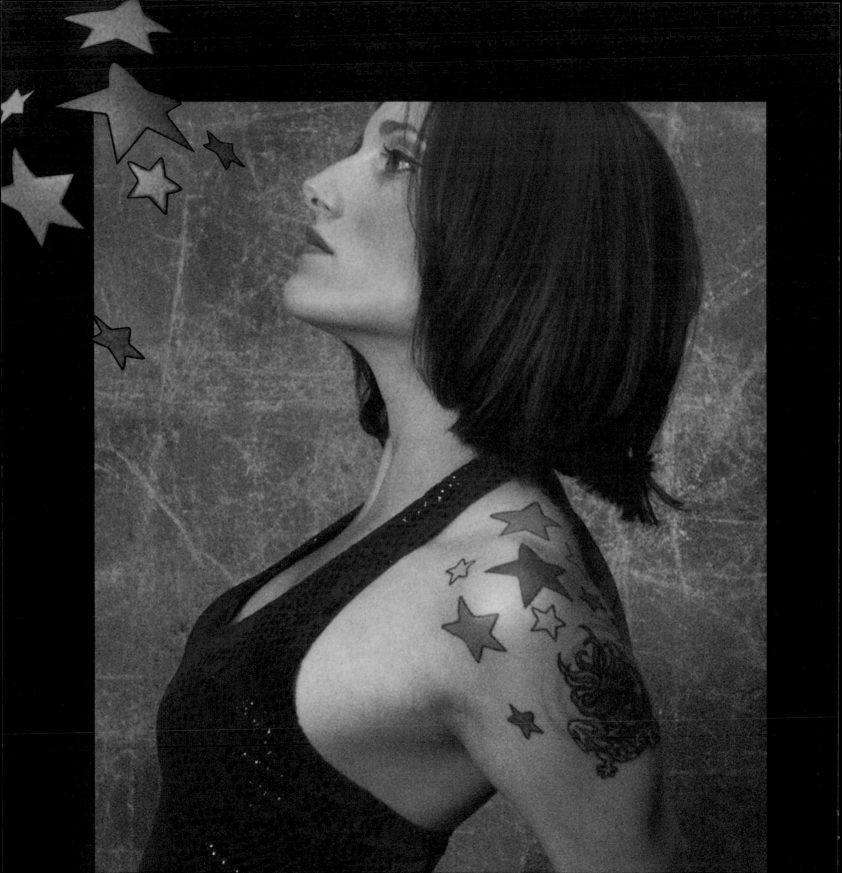

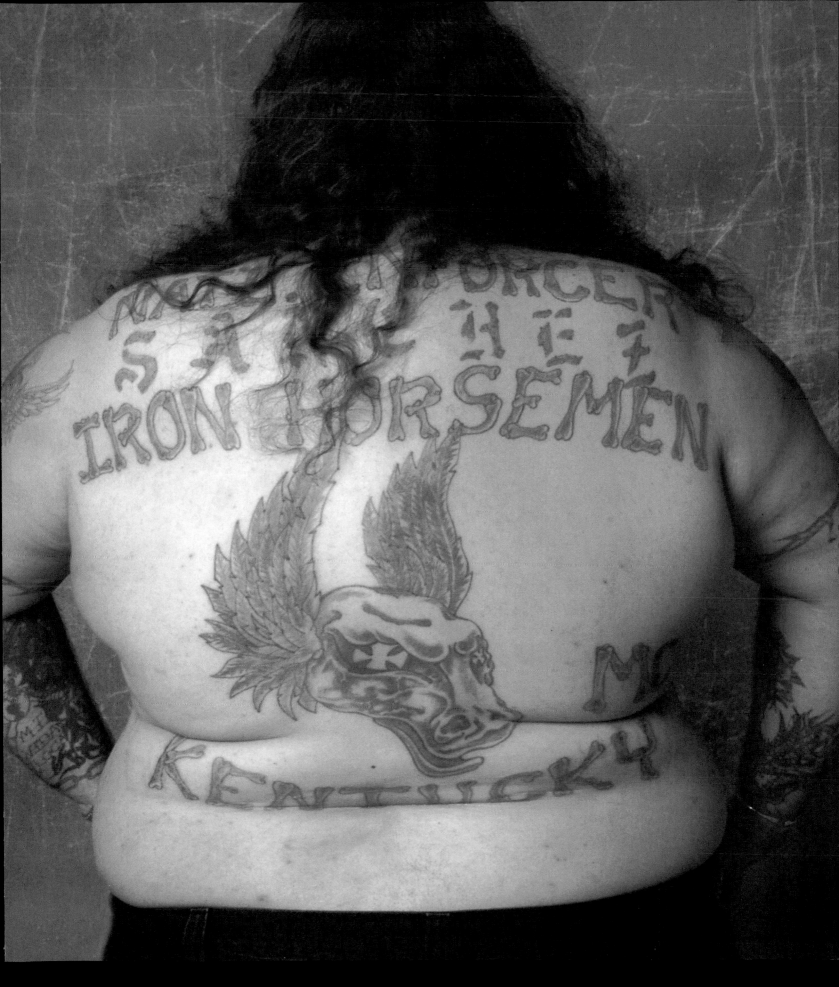

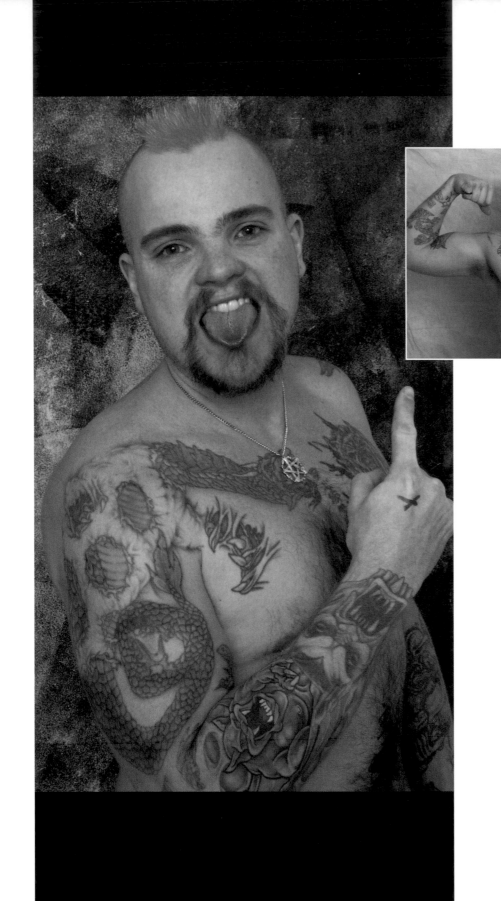

My ink evokes some negative reactions from adults and a lot of curiosity from children.

~Christopher Mattison

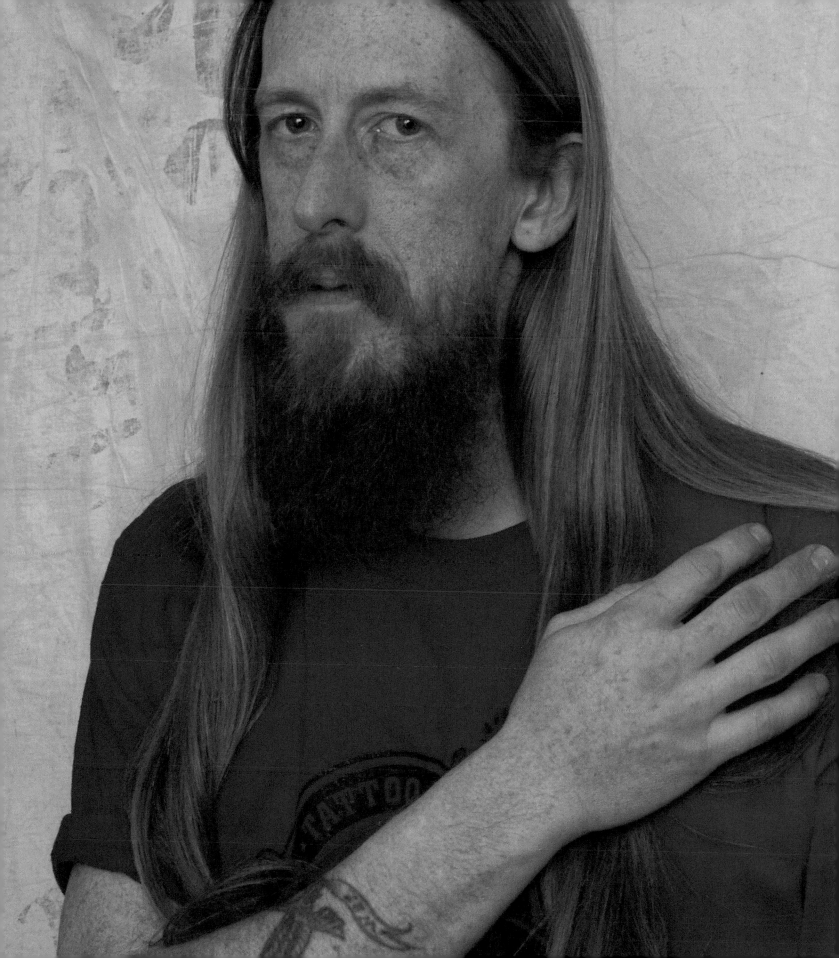

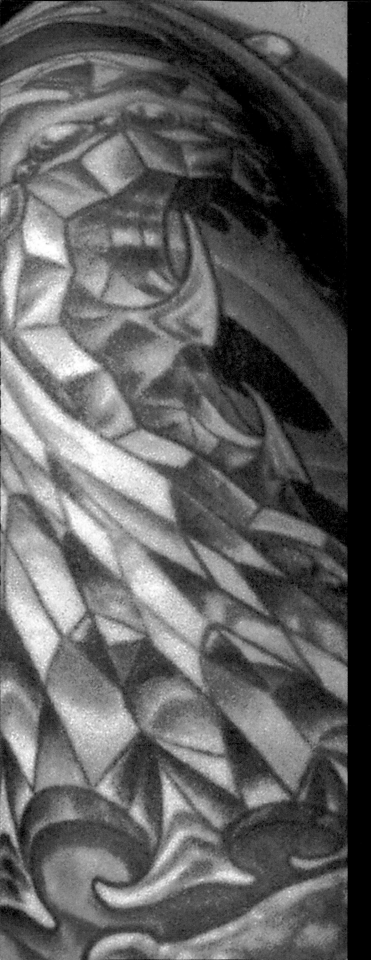

Don't ever put a name on your body unless it is your parents', your kid's or someone who is already dead.

My tattoos act as an idiot filter – they keep small-minded, petty people away from me.

Tattoos freeze frame your life at the moment that you got them — you will remember always the person that you were when you got it.

It is impossible to fully love a tattoo that was received from someone you hated. Contrarily, a good experience can make an awful tattoo seem worth while.

Getting an "in memory" tattoo too close to the time of loss can wind up immortalizing the pain instead of being a tribute to celebrate the person's life.

When I was 18, I was living a dangerous lifestyle and became concerned that when I died, I would be buried as a "Jane Doe." So I got my first tattoo so that I would be an identifiable corpse.

All of my tattoos mean something to me —some I can explain with words, and some are just no one elses business. I don't regret any of them and have plans for many more.

Eventually I will have one tattoo… it just isn't finished yet. "

~Tee Jay

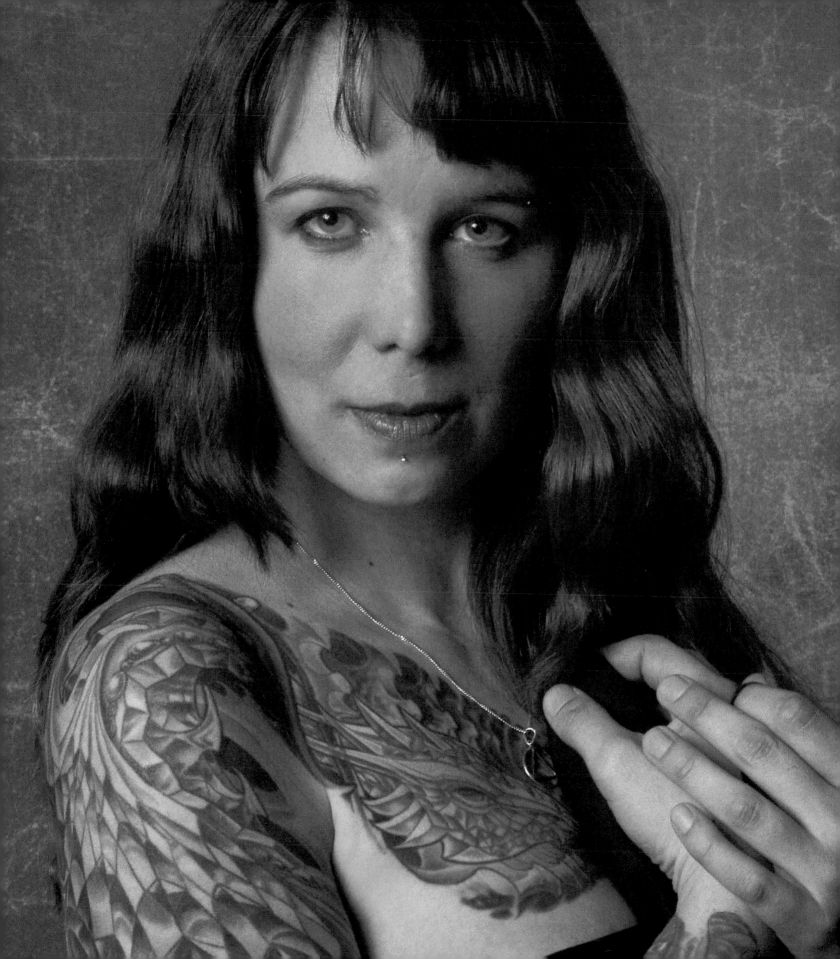

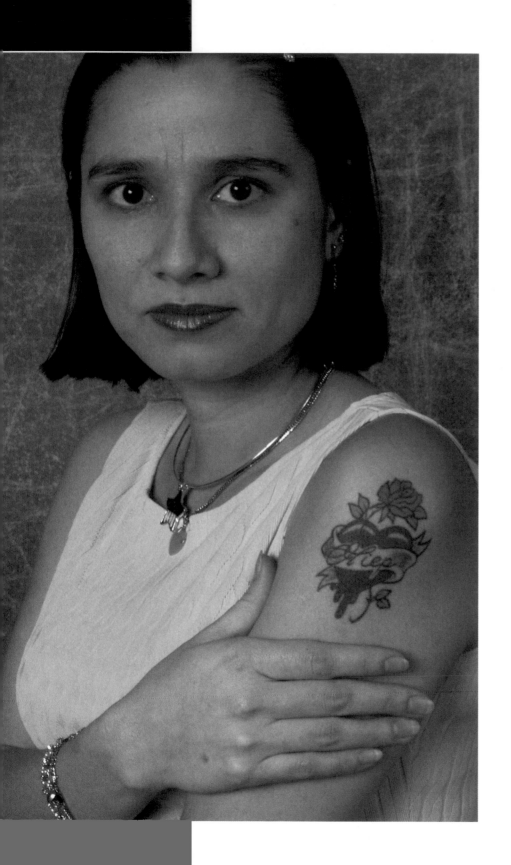

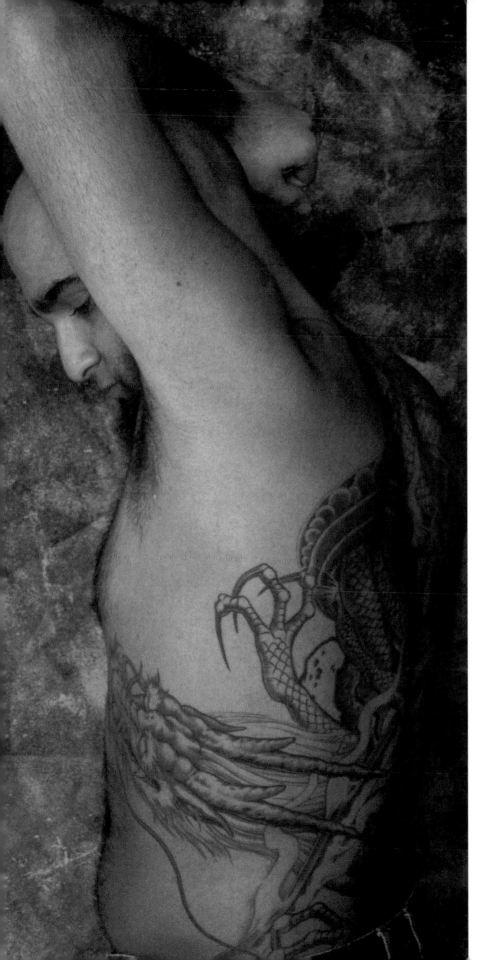

All I know is that I love dragons.
I wish they were still around! This
tattoo has a dragon and the
elements which keep things the
way it's meant to be. Wind, Fire,
Earth and Water, with a dragon
looking over it all. I didn't get
it to look cool, but it does. So
why not? This is not some way to
rebel or communicate. It's for me,
but I love to share it with people
who give a damn.

~Shahin Alvandi

i am 54 yrs old. i was a working artist all my life. i gave it up. i now raise my 4 year old daughter alone. i wanted to make my art...us.

For myself, i'm sort of redesigning, revealing myself. For Helen the "art" is in trying to raise a happy, healthy, balanced, strong, creative, honest, aware person.

~Robert Imbrosci

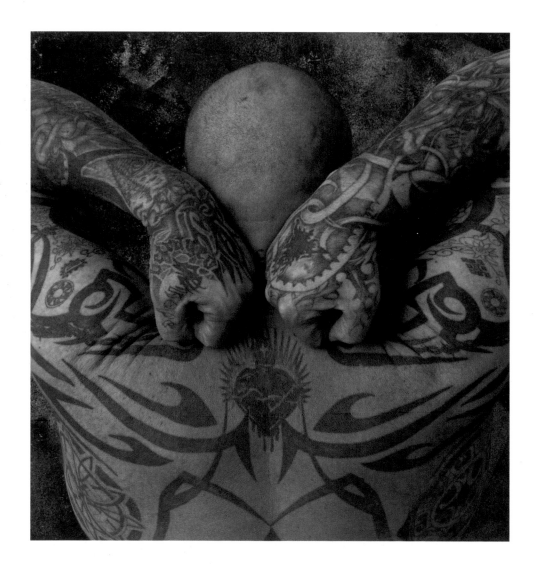

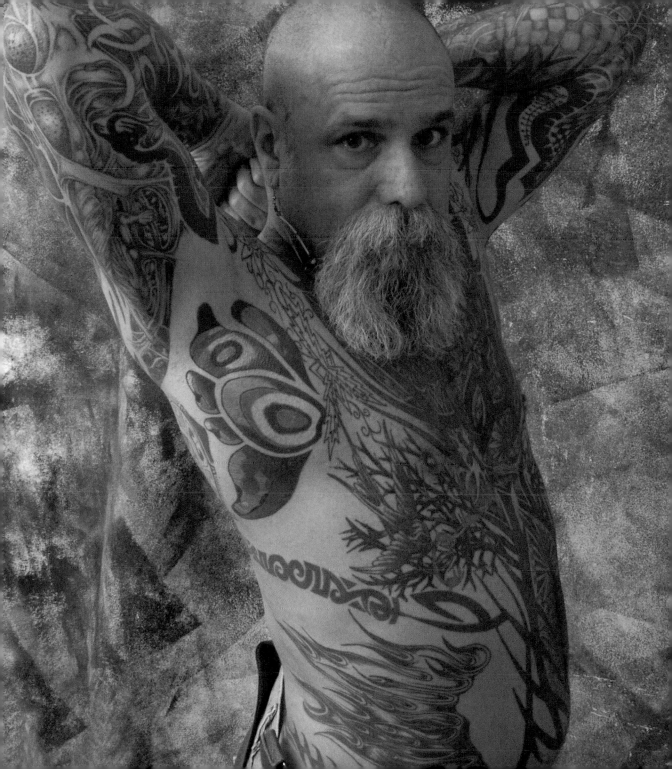

People should take the time to talk to me before making assumptions. Most people's first impression is wrong. I'm the kind of guy that has bullets in one pocket and marbles in the other.

~Devin Rayow

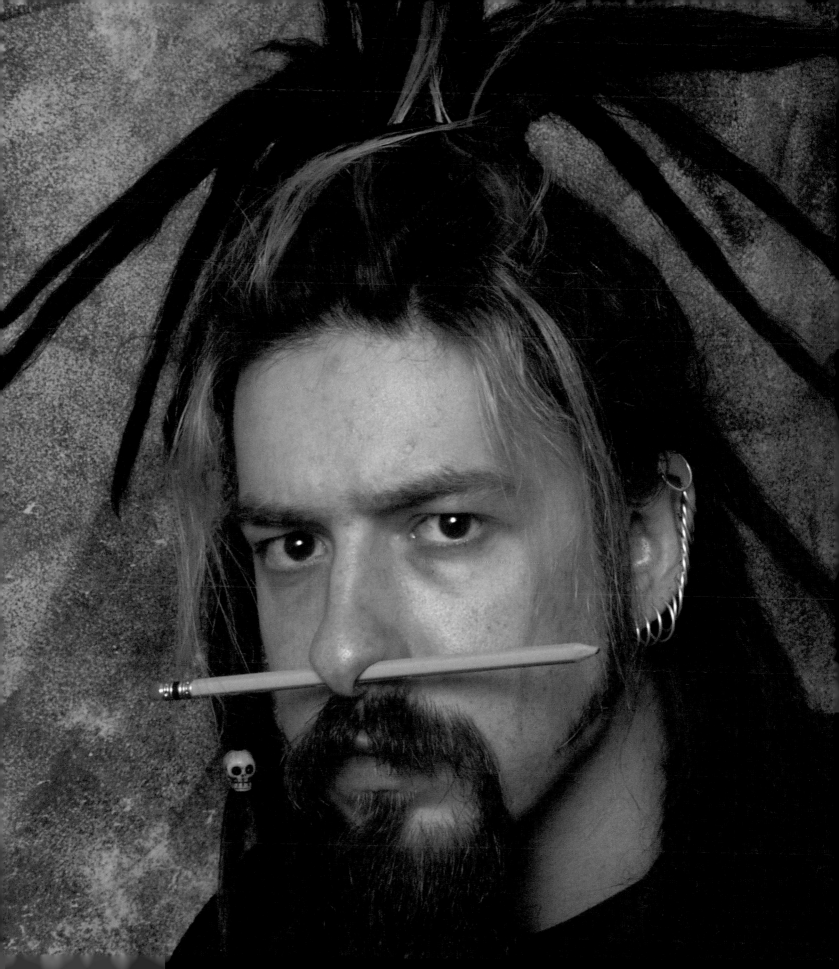

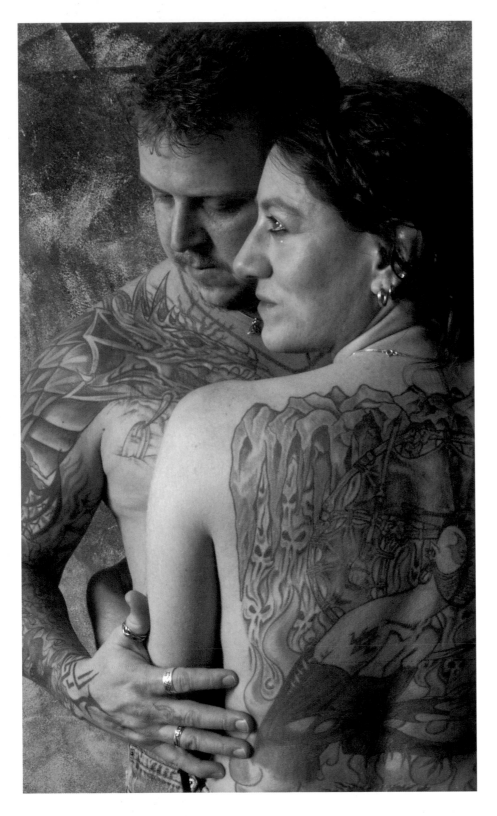

Inspired by an ink-filled flesh fantasy.

my inspiration was love of the art.

My family was horrified to see my back.

~Jim & Kelly Wolcott

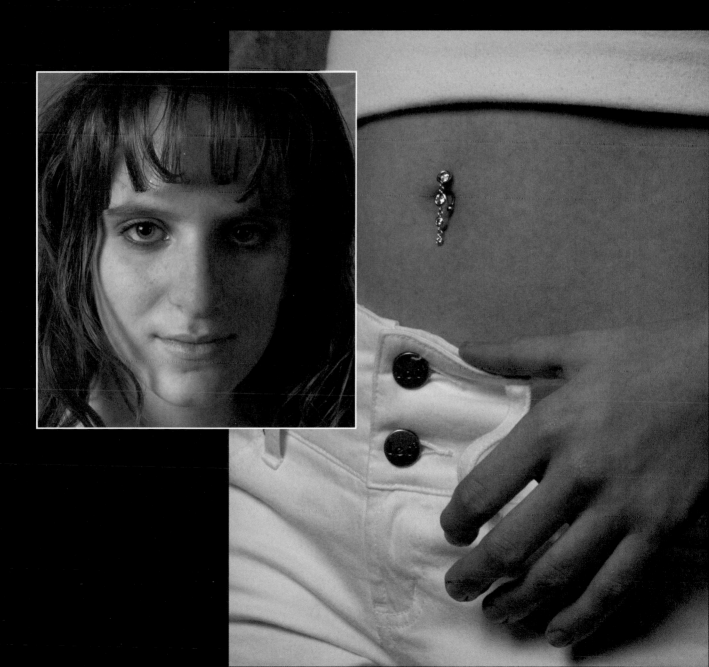

Young girls feel it raises their self-esteem because they are proud to show off their new jewelry which they have chosen to make their own unique statement.

~Kristen Pelliccia

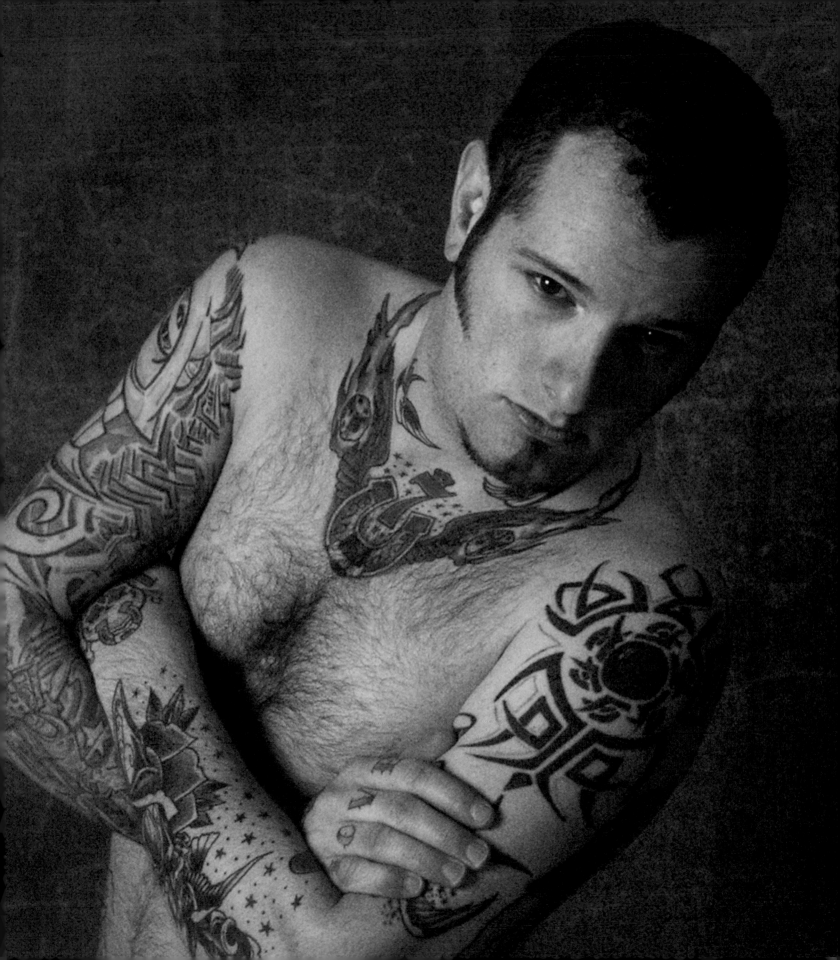

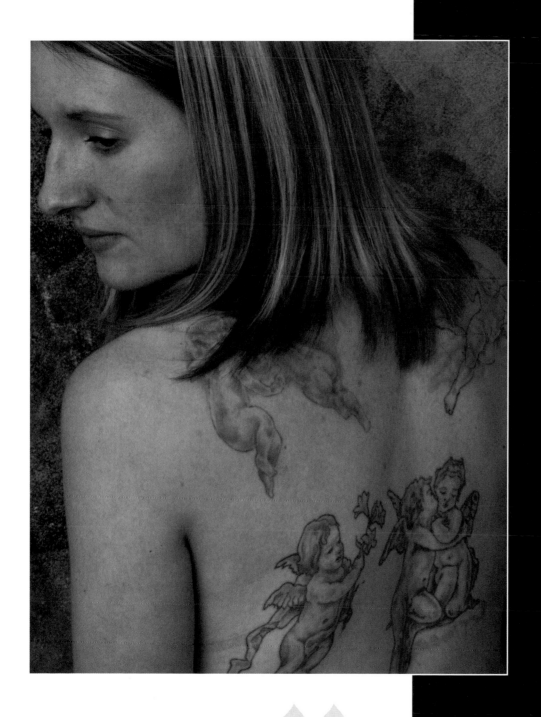

"I got my first tattoo when I was 16 of a cherub, and quickly became addicted.

~Melissa Burke

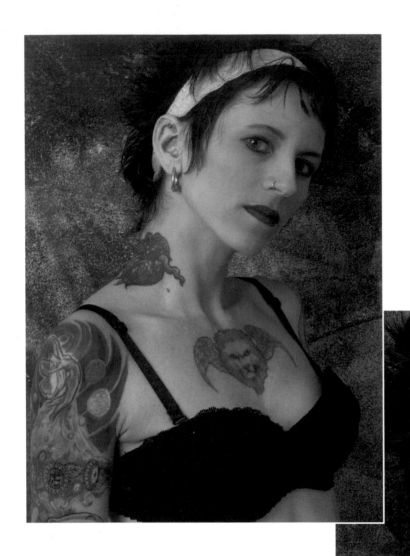

I HAVE ALWAYS BEEN A VERY
FLASHY PERSON AND MY TATTOOS
ONLY ADD TO MY APEARANCE. TO
ME IT'S JUST LIKE ADDING
ANOTHER PIECE OF JEWELRY TO
MY COLLECTION.

~DAWN EHLERT

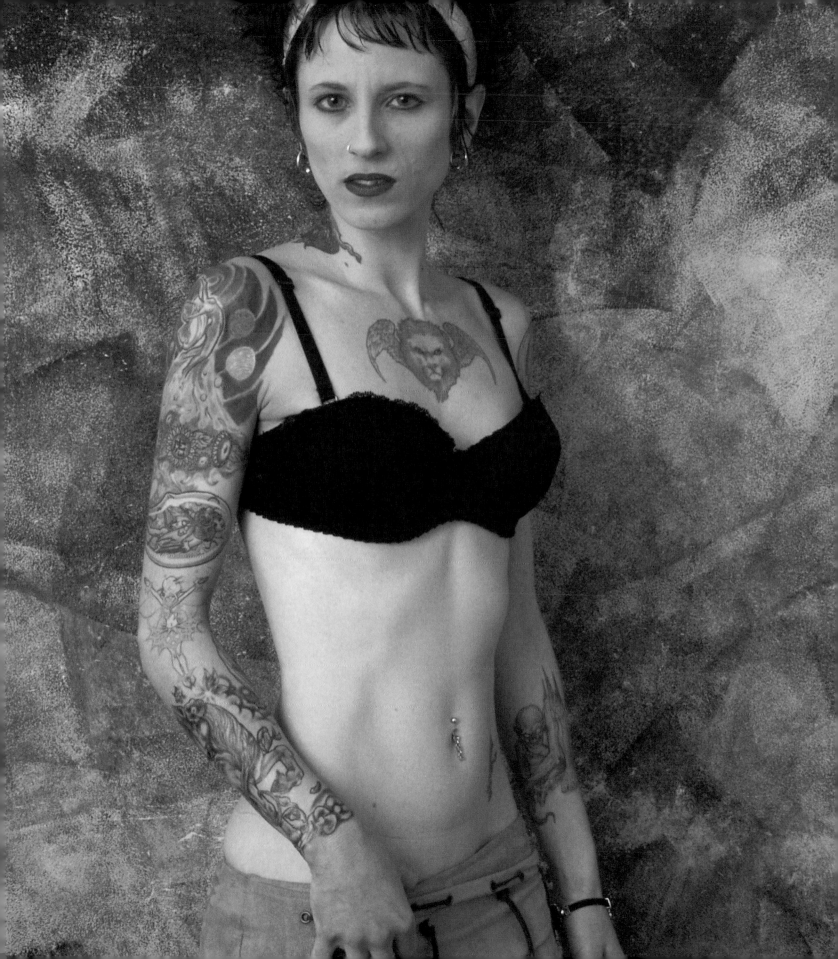

I DON'T REMEMBER MUCH ABOUT MY FIRST PIERCINGS. I THINK MY MOM GOT MY EARS PIERCED AT A DEPARTMENT STORE WHEN I WAS FOUR. I DO, HOWEVER, REMEMBER CRYING. A LOT!

~KIMBERLY JENKINS

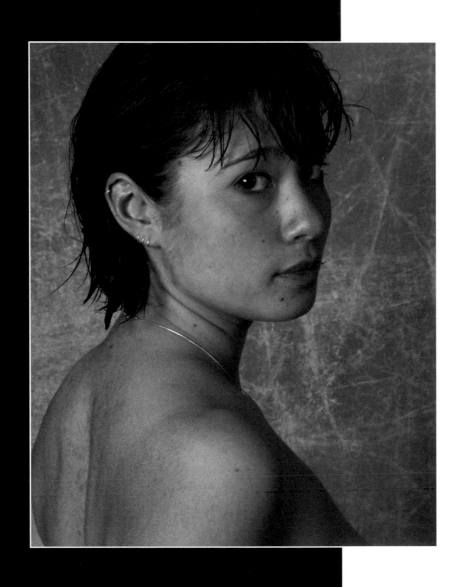

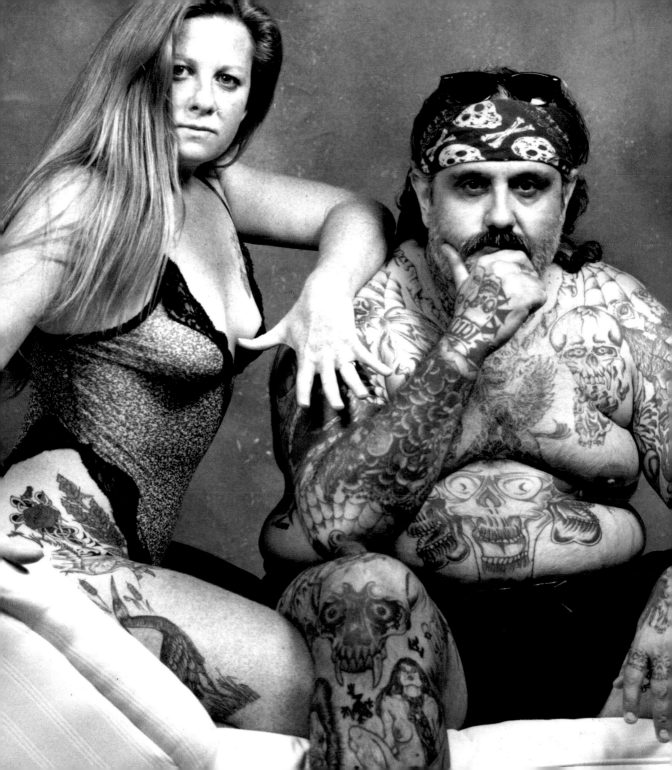

In grocery stores, parents sometimes grab their children and pull them close — like I'm going to eat em.

~Ashford Happer

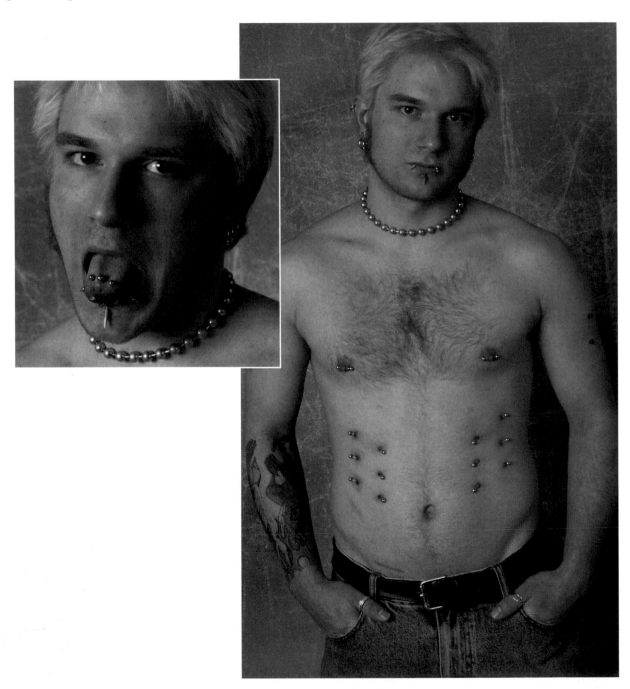

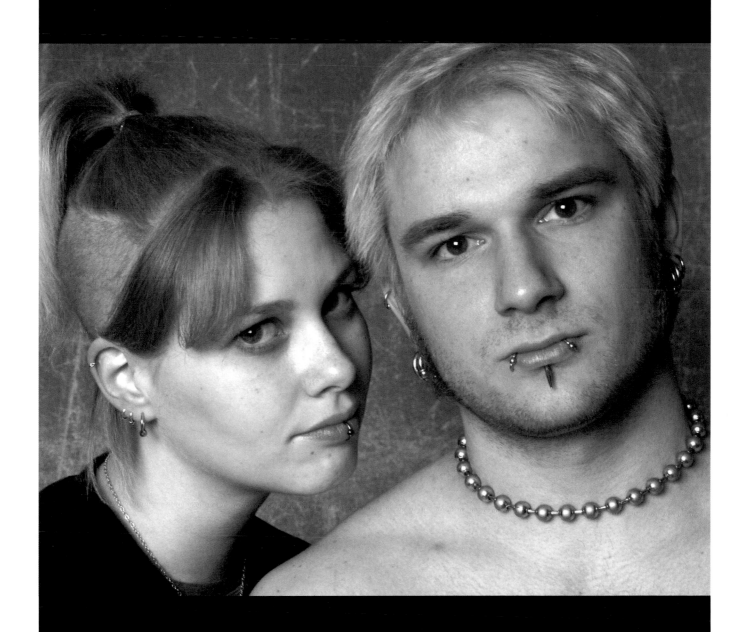

My family has never forgotten that no matter how many holes I put in my body, I'm still the same person inside.

~Lisa Williams

i'm a pistol packing, motorcycle riding, cookie baking, kind of girl.

~Kristen MacConkey

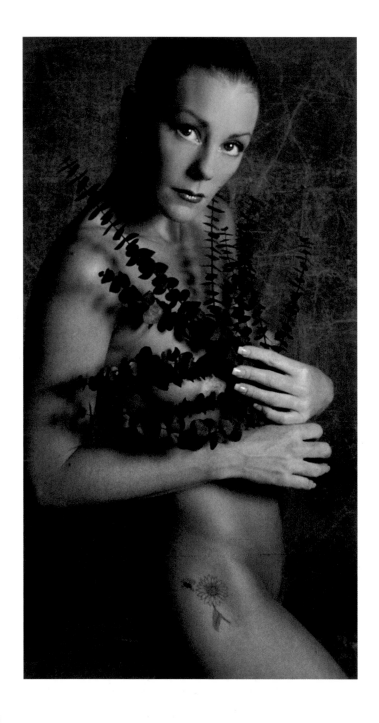

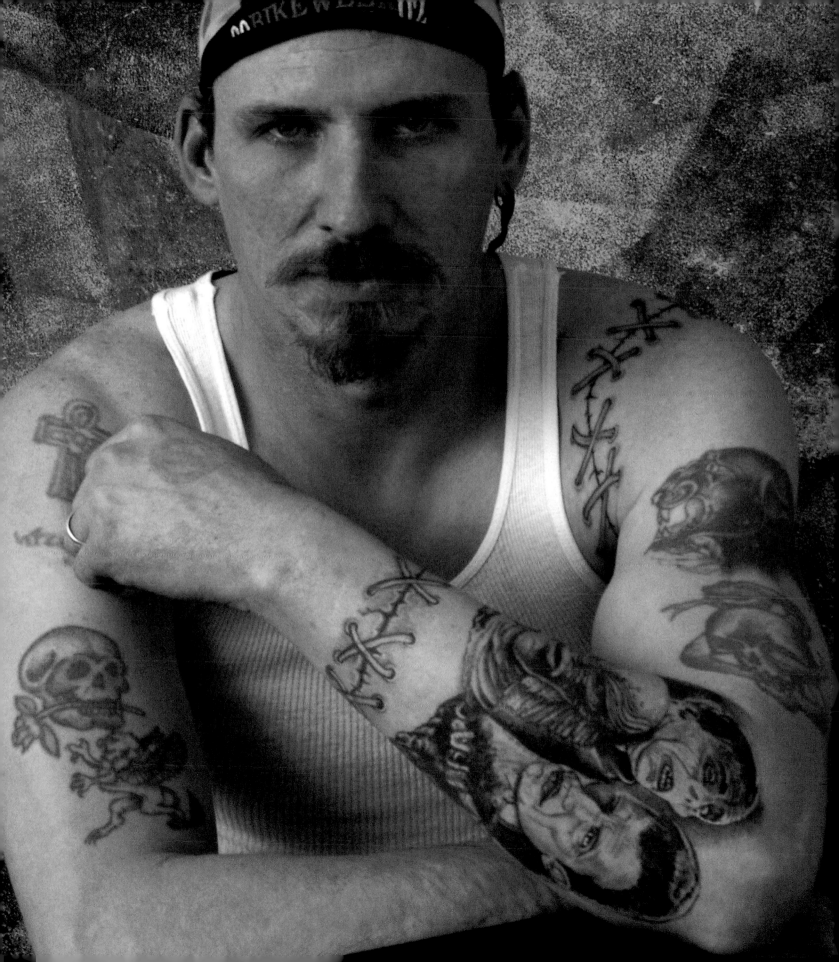

In my opinion, tattoos are a way to beautify what you might not like about yourself. Certain features that you feel need improvement. What better way to improve something than by art.

~Jessica Allison

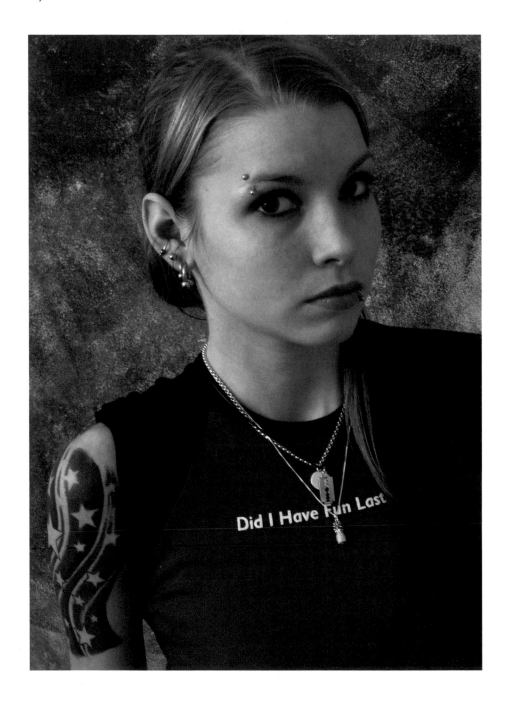

CRAZIER THAN A SHIT HOUSE RAT ""

~GABE CLIEWE

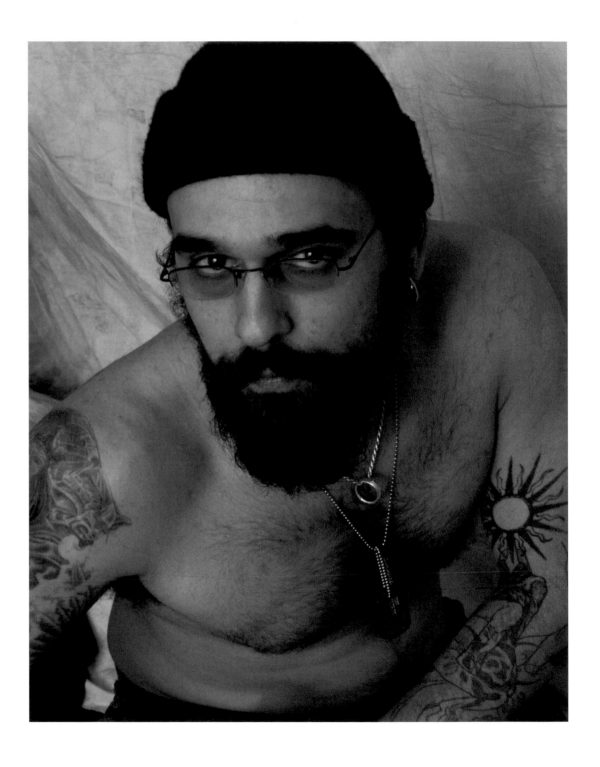

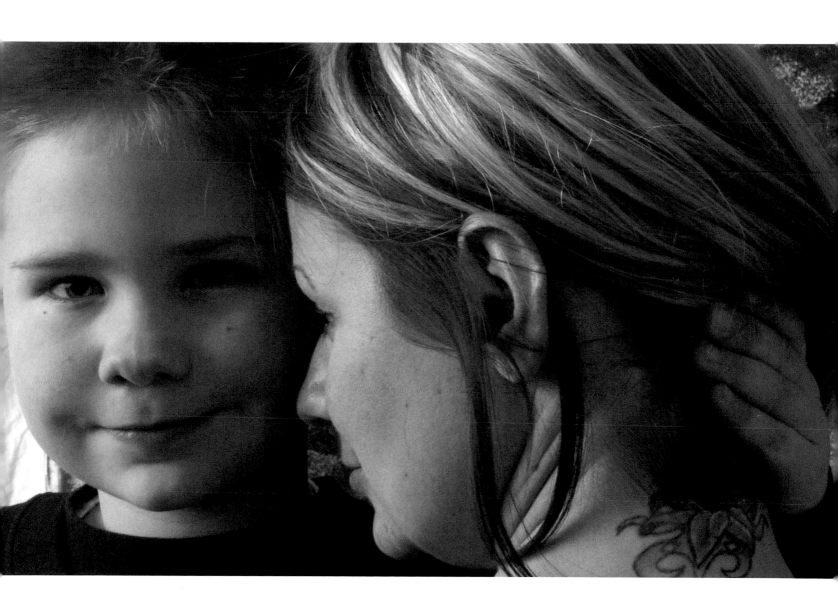

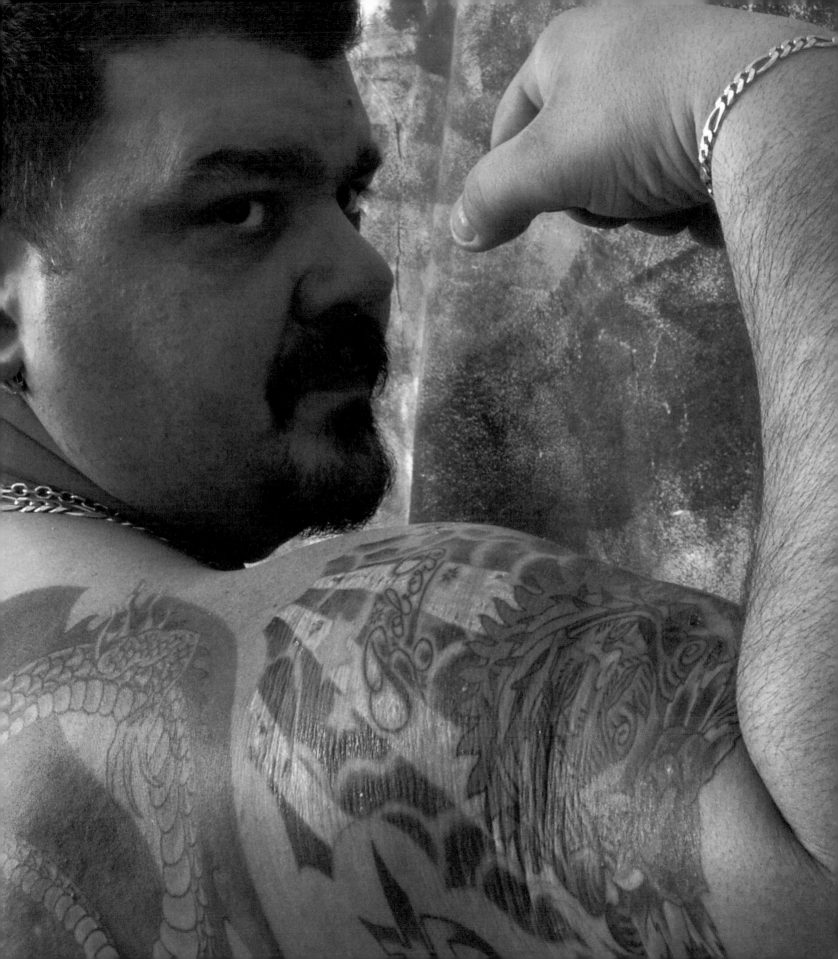

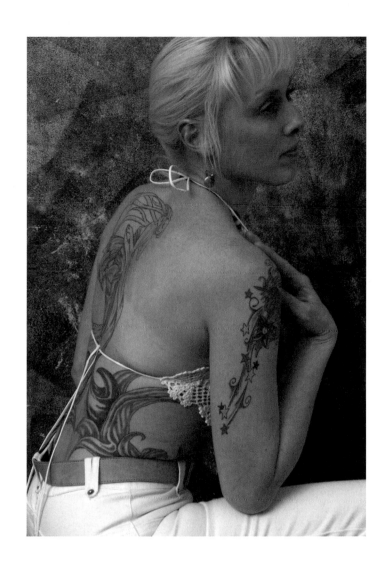

My inspiration for getting a tattoo was my love for art nouveau/art deco. Erté & Alphonse Mucha were, in my opinion, the best art nouveau/deco style artists. The woman is from Alphonse Mucha's "The Dance" — hair changed to blonde for me.

I am a registered nurse, paramedic in a very busy emergency room & am currently apprenticing to become a tattooist — hopefully by this summer. My love for art is greater than my love for treating our "ill population."

~Sue Cummings

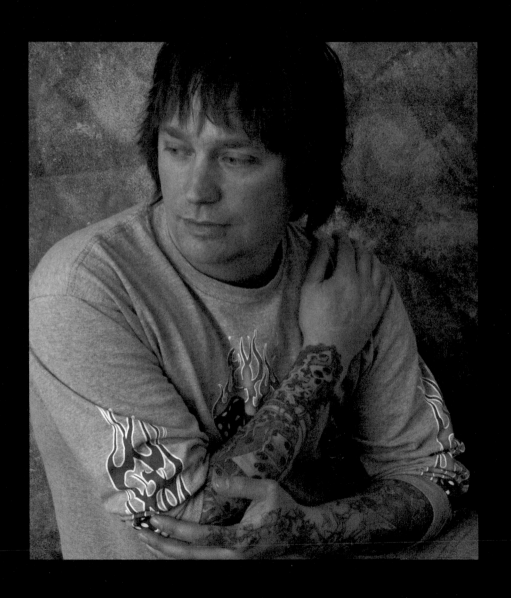

Be for the art, don't sell out! "

~Cara Zuckerman

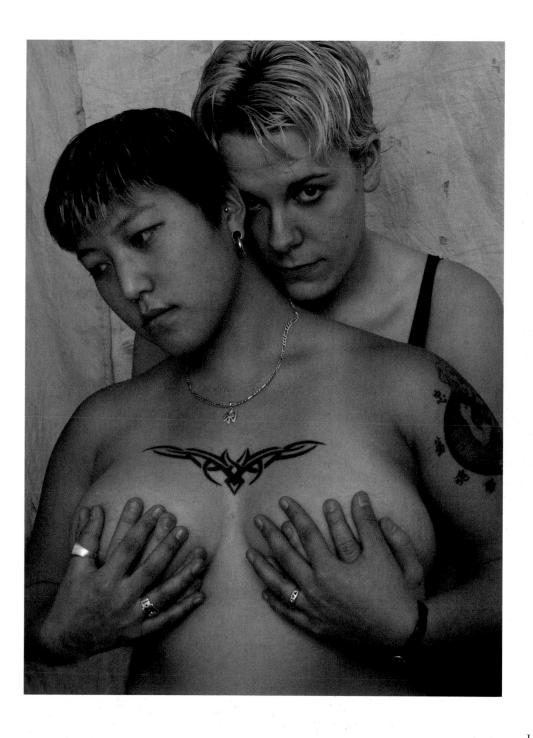

A lot of people judge me because of my tattoos, and some people think I'm a criminal because of them.

~Michael Bronson

My inspiration for getting my first tattoo was my mother. She passed away when I was 12 and always remembered her saying how she wanted to see me get my first tattoo. So in memory of her is why I have the Pegasus on my shoulder. It is the same exact one I remember tracing with my finger when I was young, looking in amazement of its and her beauty!

~Rebecca Bronson

My late wife Barbara was into tattoos and she was an inspiration in some of my designs as I would run ideas by her and she would give me input. When she passed, it was an inspiration for my daughter to get hers. My son also is into tattoos and it's an honor to me that he shares my lifestyle & interests.

~James Bronson

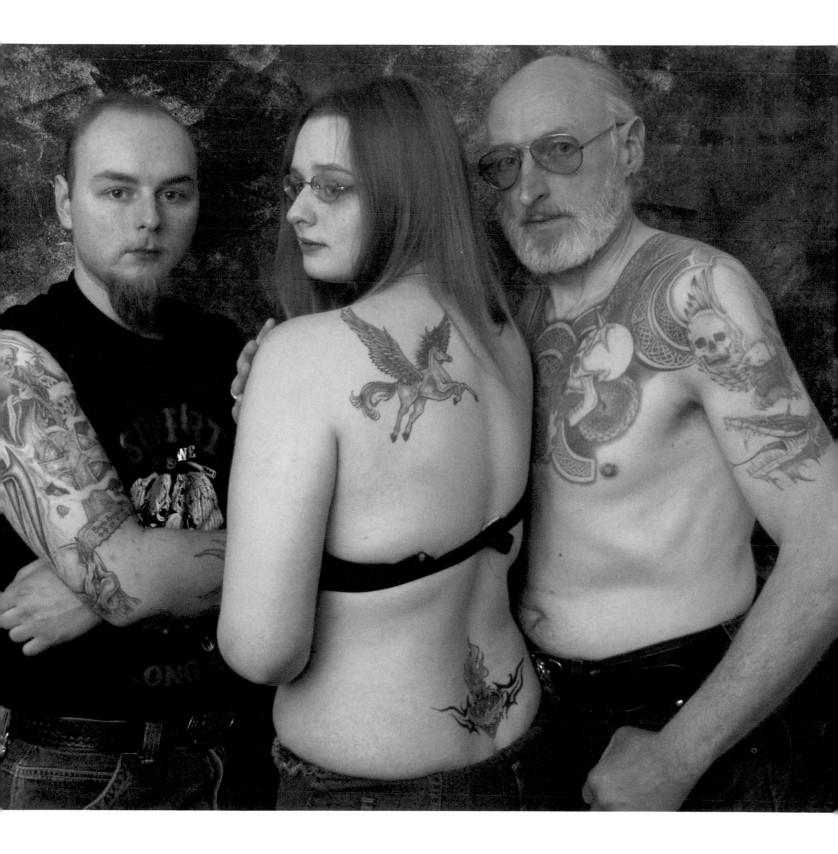

If you wonder if it hurts: yes of course, but it's worth it. It tells a little about you and its only temporary pain for permanent beauty!

~Tina Gilmore

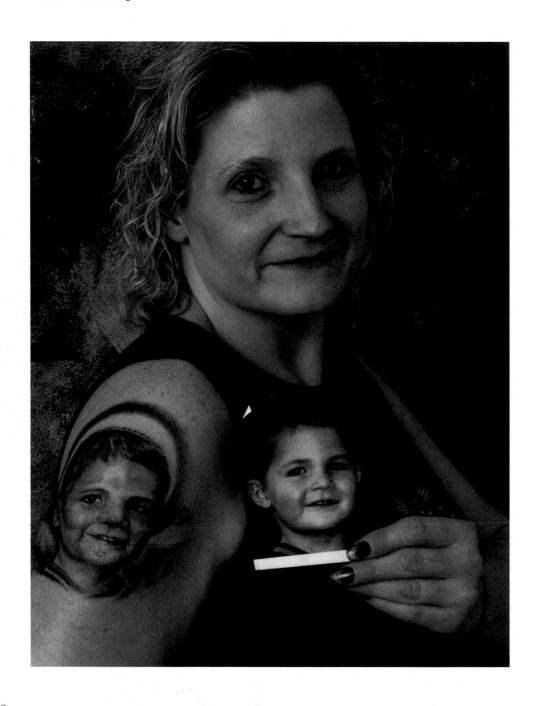

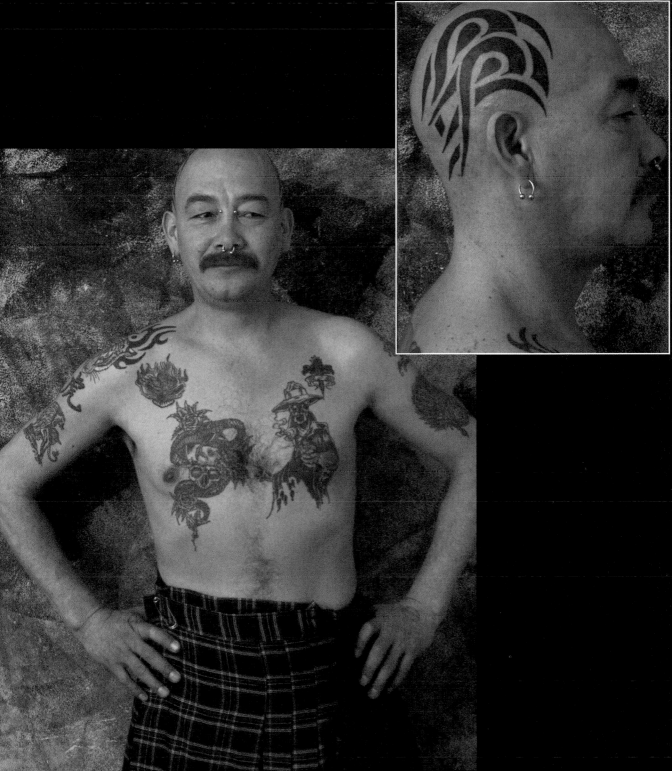

SELF EXPLORATION — PUSHING MY IMAGINED
LIMITS, PHYSICALLY & SPIRITUALLY. PIERCING
MYSELF WAS VERY PERSONAL — ENLIGHTENING.

~COLIN RAY

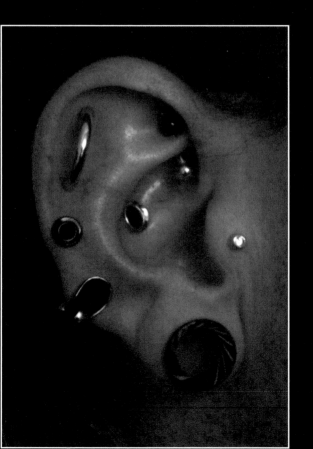

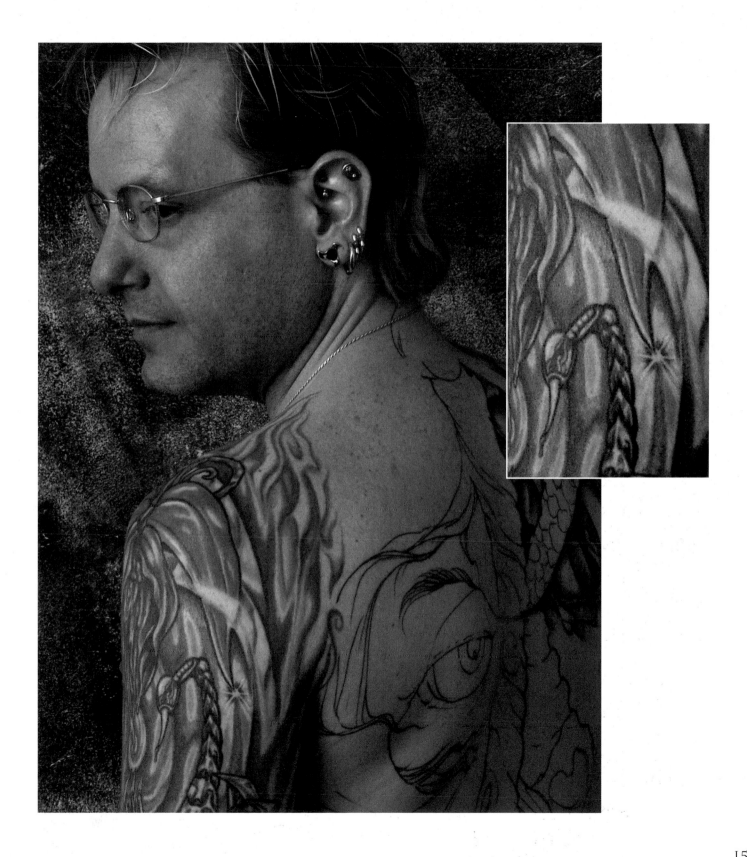

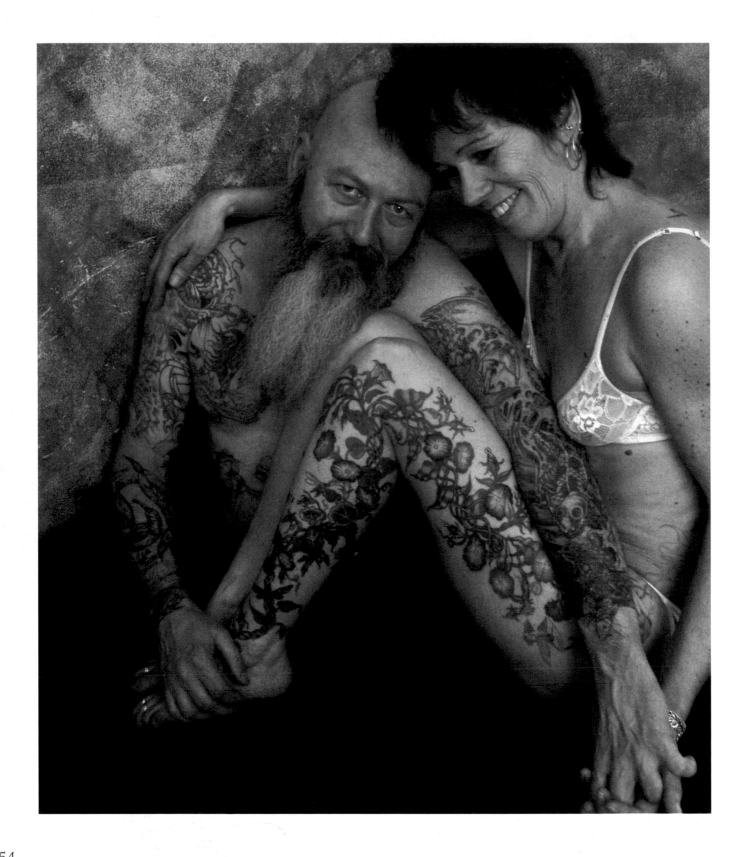

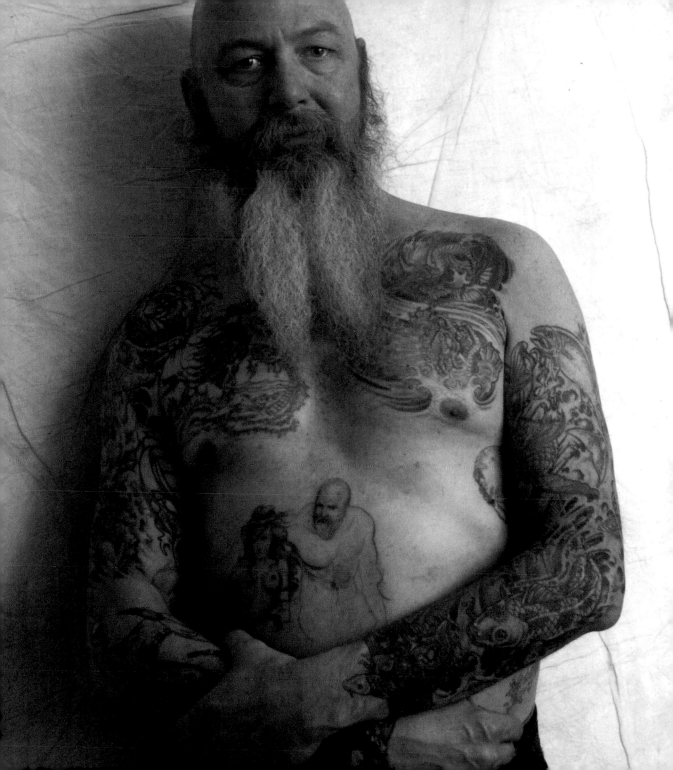

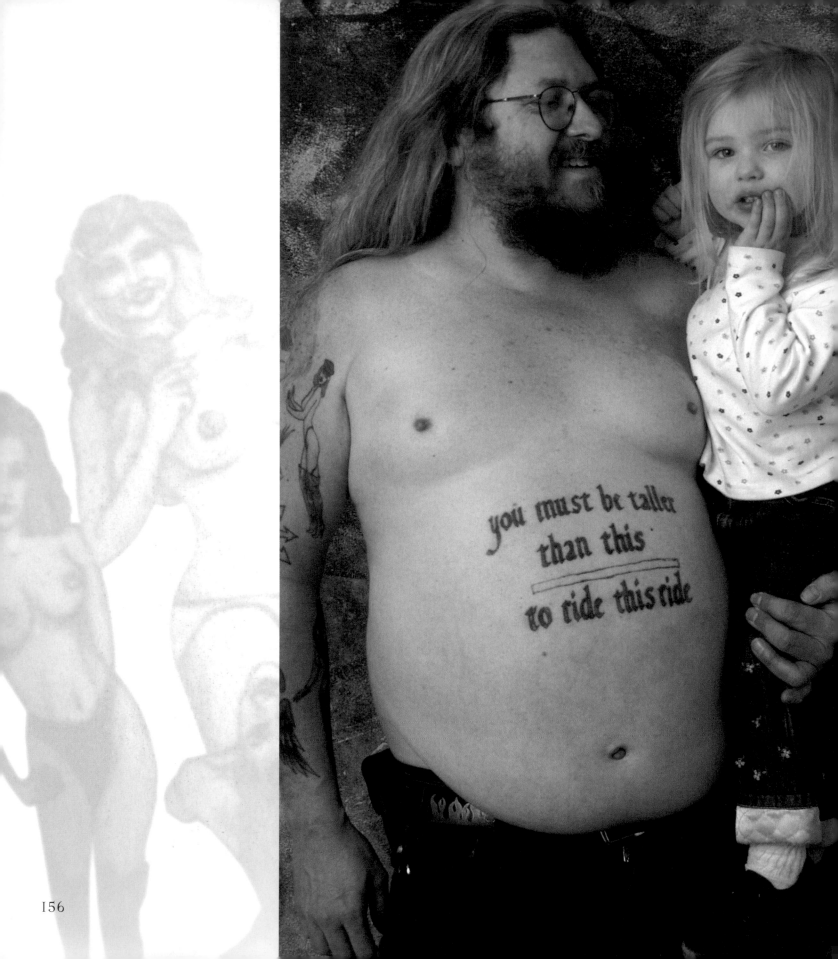

"The tattoos I have are for me. If other people don't like them: too bad for them, because most people are not good enough to get one.

~Jeffrey Denoncour

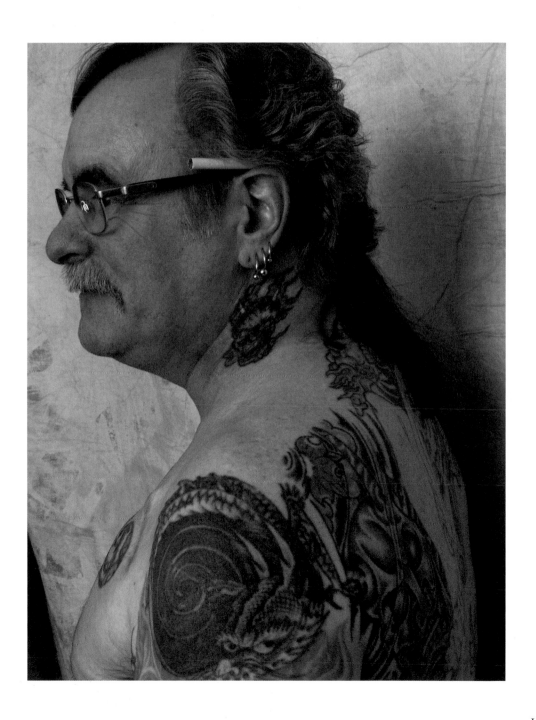

"Watch out for the quiet ones" — I think that best describes not only my family's reaction but also my acquaintances. Most people would call me quiet and understated; my tattoos are generally a surprise. But, and this is important — to me, part of the beauty of tattooing lies in the fact that you can portray very personal and profound elements in the design — but you may choose to show the tattoos to only those people you choose. So, while I am a funeral director, I can be discrete to my work and no one has any idea of all this beautiful artwork.

~Lee Minier

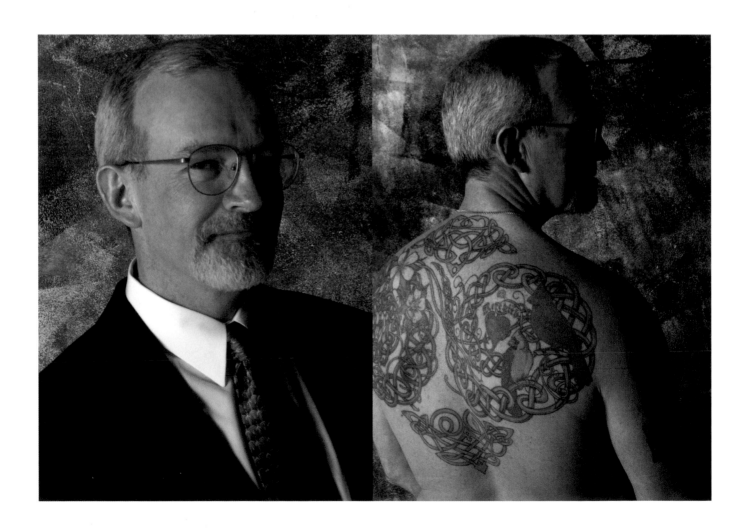

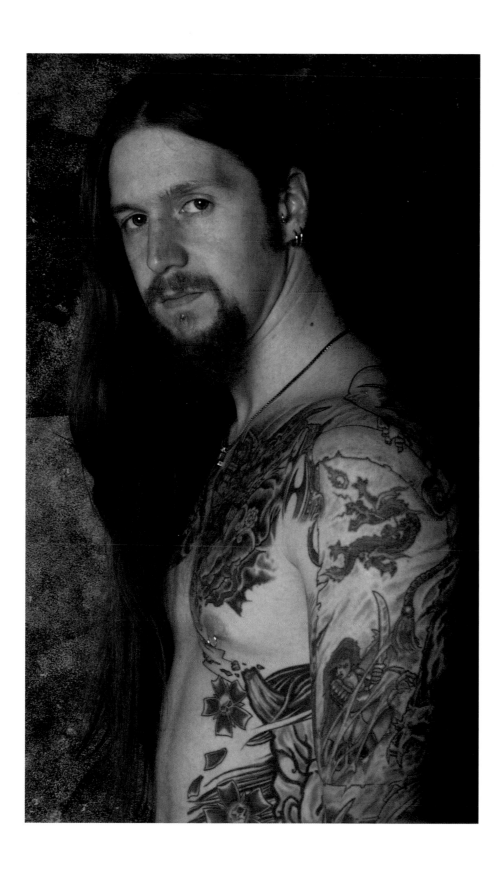

I was only going to get one tattoo when I started out. I'm still only gonna have one... a big one.

~Jason Reifsnyder

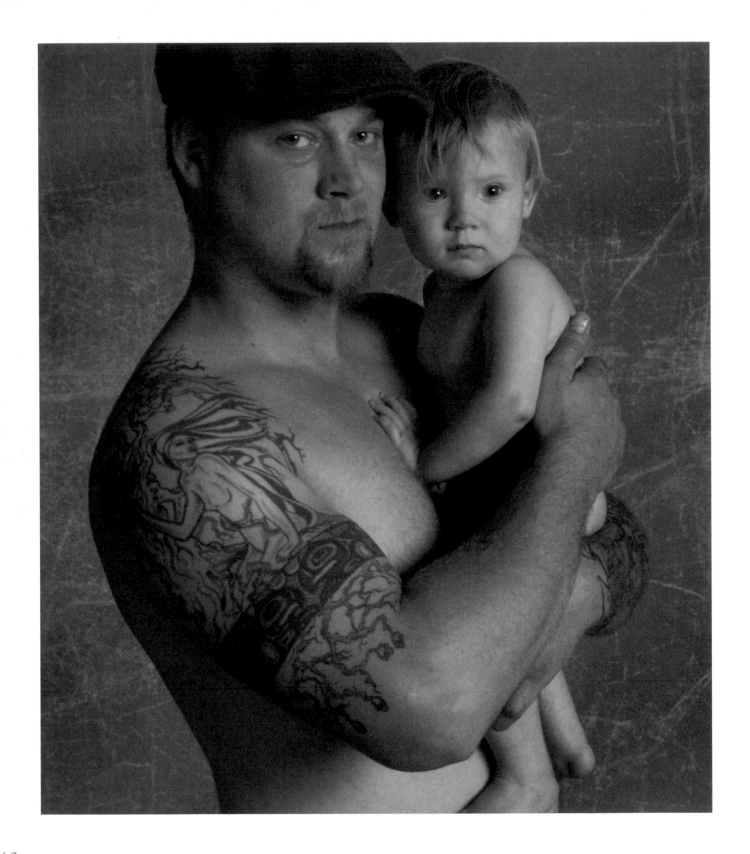

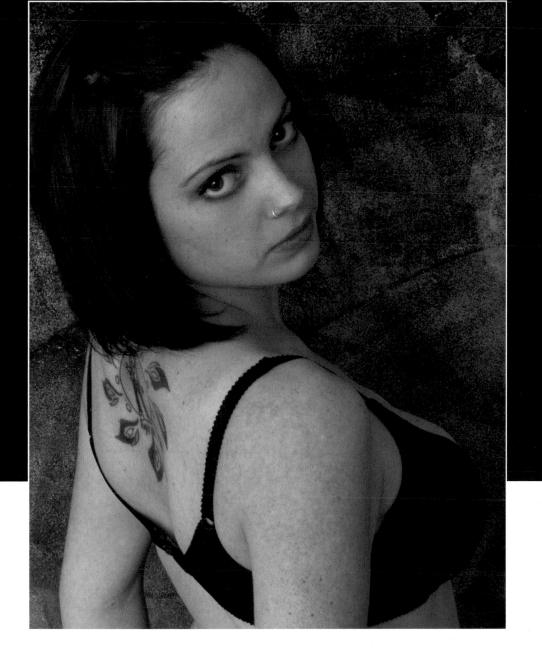

Movement is my inspiration, to speak without words. to dance
through life.

~Myah Faraone

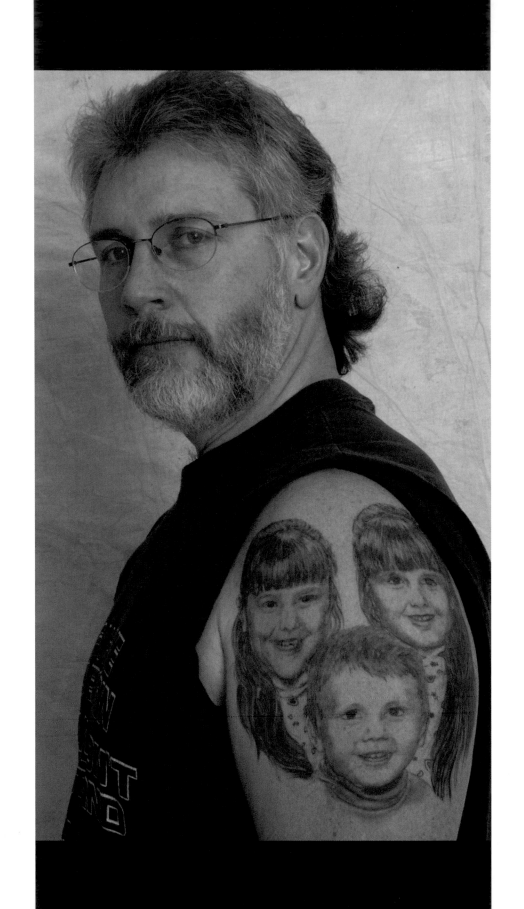

When I met my boyfriend (who is an artist), I fell in love with his work. At that time I didn't have any tattoos and decided it was time to get some of my own artwork. Within a 2 year period I now have 13 tattoos, one being a full leg piece — and I love every one.

~Lori McBride

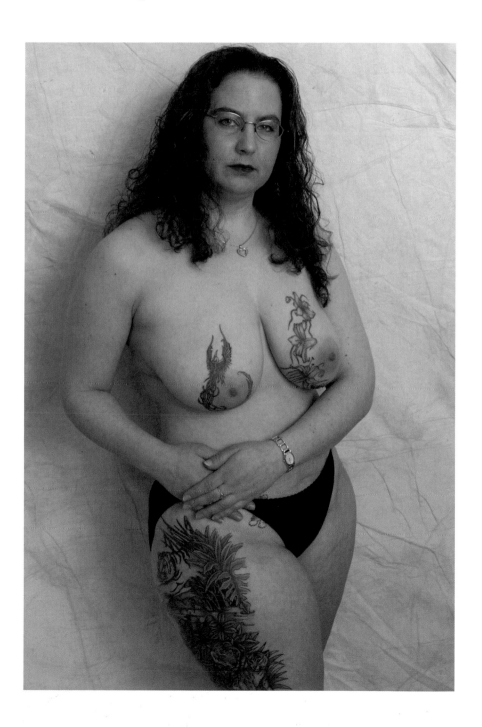

I don't care if my tattoos bother you. don't care if I bother you. I wasn't put on this earth to make friends.

I've caught hell for some of my contentious tattoos in the past. And I know I will in the future. But the thing that keeps me doing it has never been other people, it's been me. So piss on 'em.

~Dave Ladwig

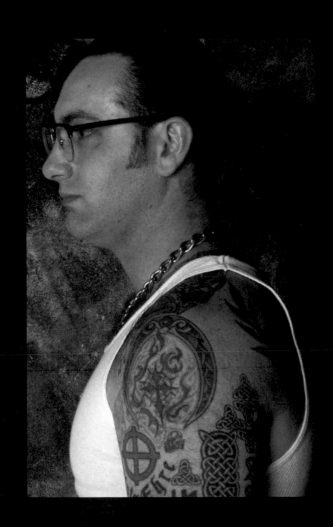

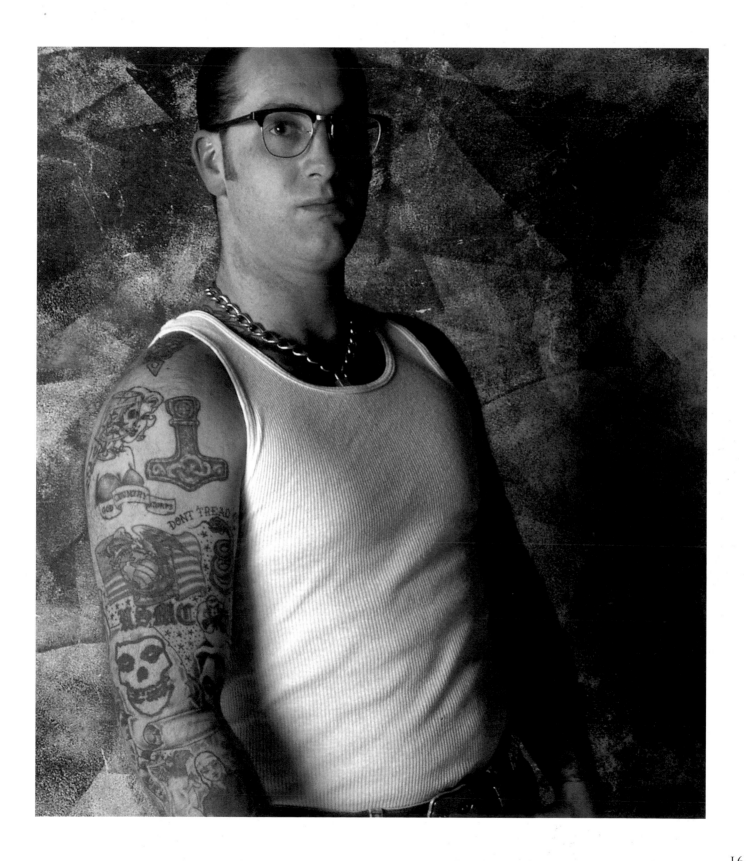

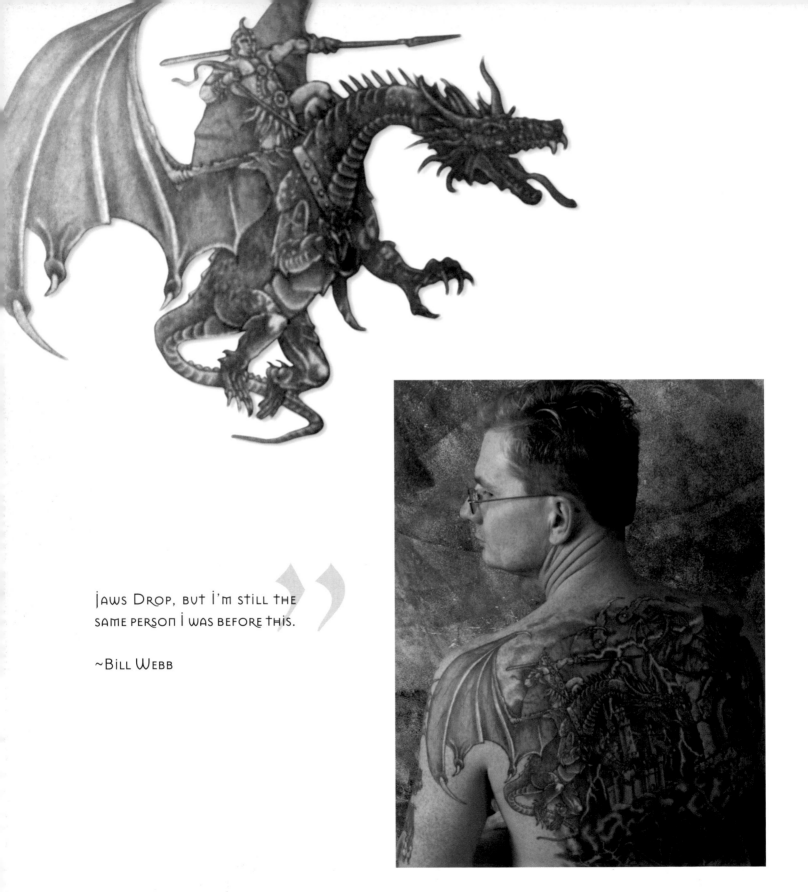

JAWS DROP, BUT I'M STILL THE
SAME PERSON I WAS BEFORE THIS.

~BILL WEBB

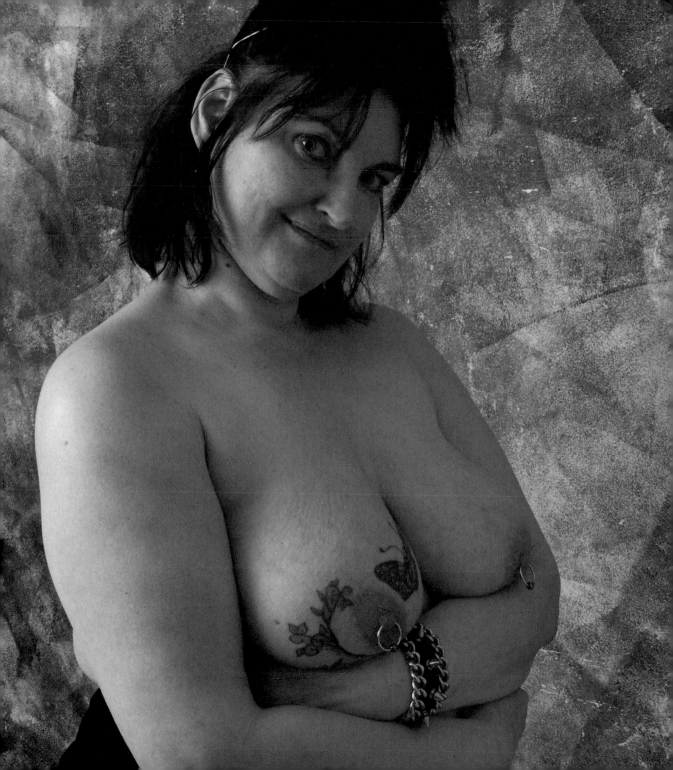

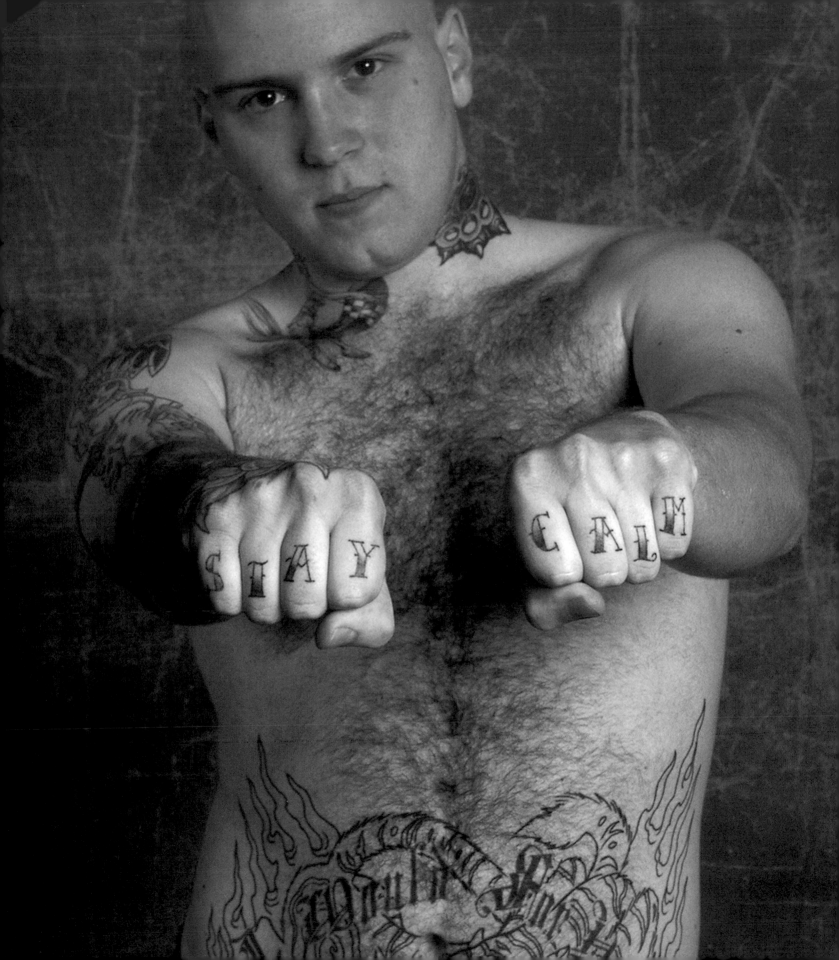

There are many reasons why people are into changing their bodies. For some it's about control, for some it's about pain. Still countless others are in love with the sheer art, skill and talent. I on the other hand, do it because I really hate getting up early in the morning.

~Brian Wahl

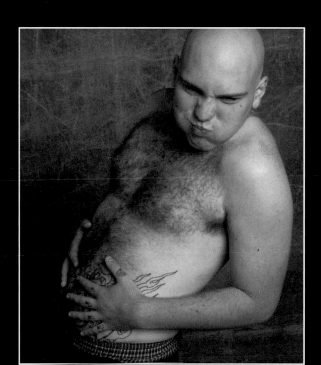

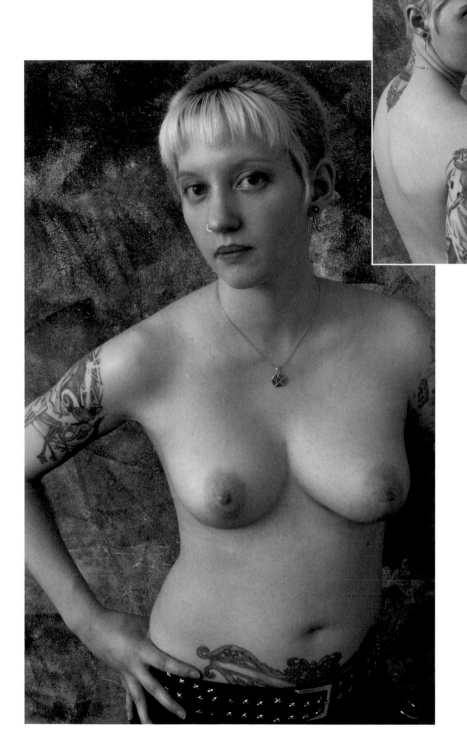

My body is a temple and I enjoy decorating it. Many of my tattoos are spiritual, and I am a practicing witch. Wicca is a religion full of symbolism.

~Suzanne Beam

Once I suit up (have a full tattoo body suit), you will be able to understand more. Only then will you see "I am."

~Kristina Klingler

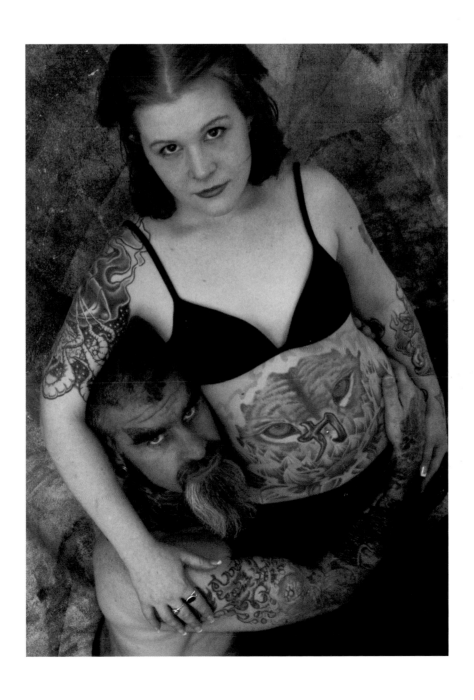

I was a bored wedding photographer and was interested in tattoos, so I learned to become a tattoo artist.

I also became an ordained minister, and now offer free cover up work to kids who have satanic tattoos.

~Eric Schultz

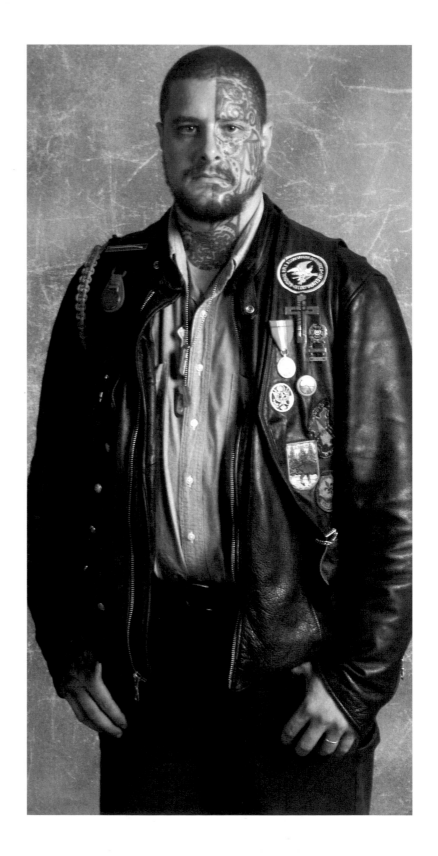

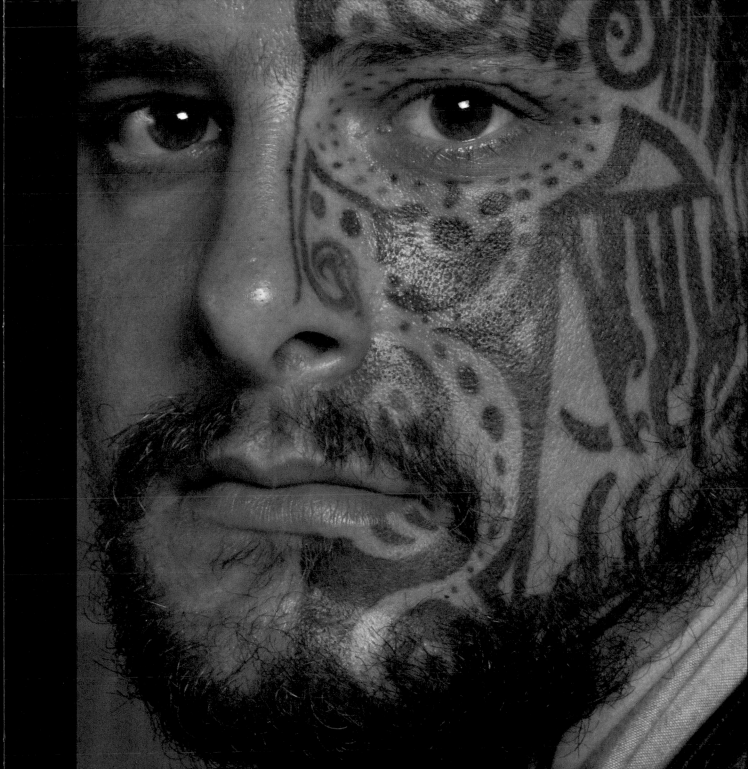

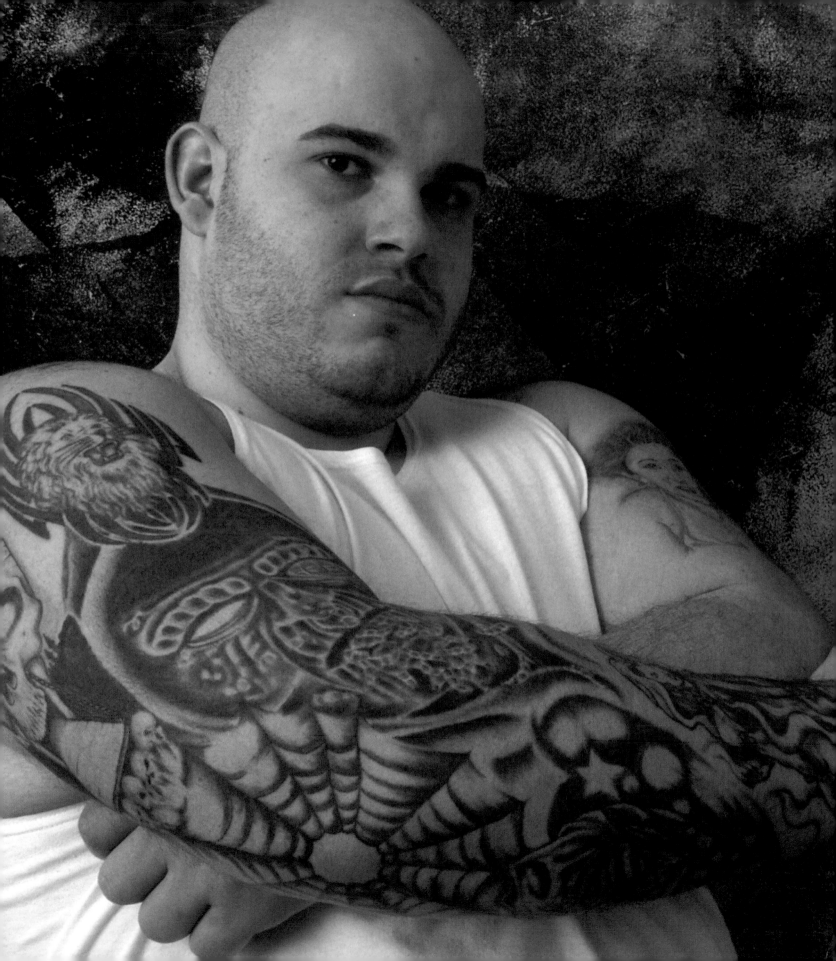

I'm always thinking " " about the next piece.

~Carole Meader

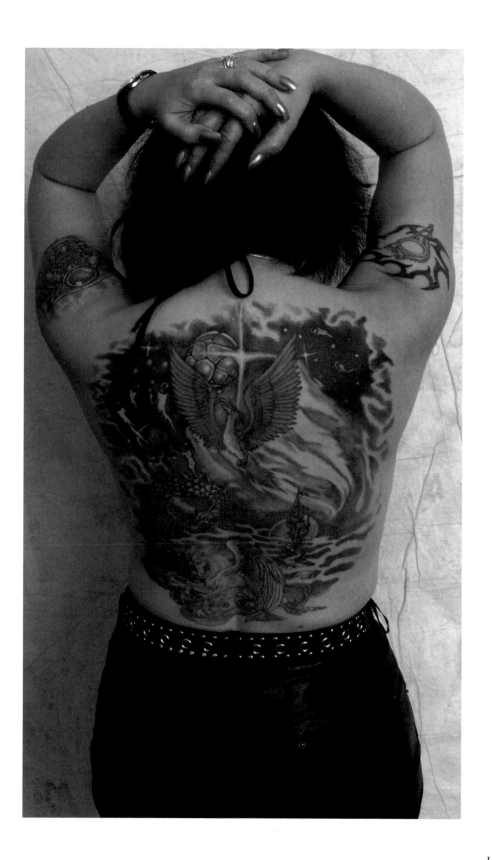

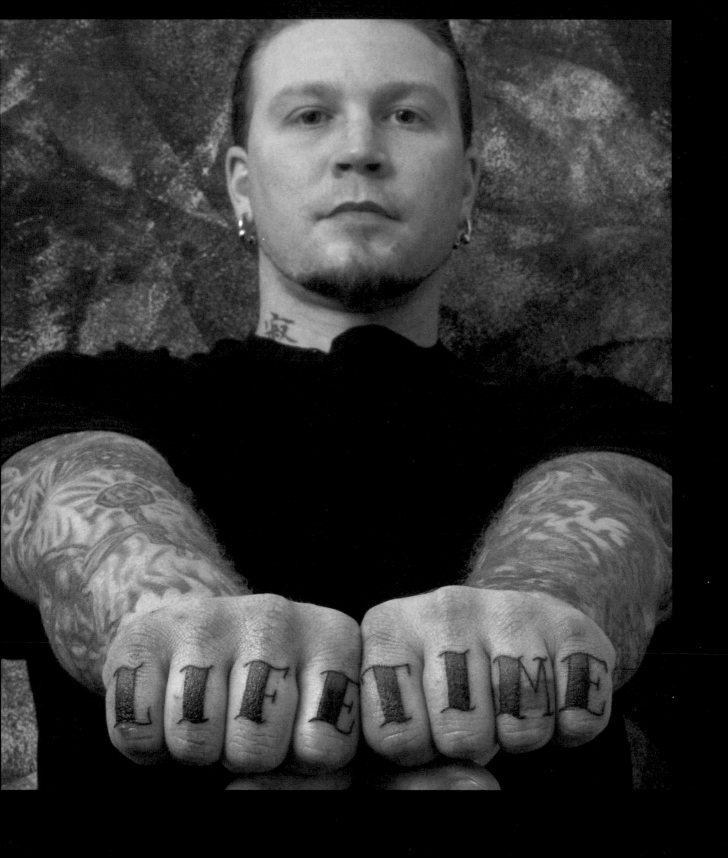